SECRET ILKLEY

Mark Hunnebell

AMBERLEY

...But Read. Read the newspapers of that time. Every age becomes mitigated and a little ennobled in our minds as it recedes into the past. It is the part of those who like myself have stories of that time to tell, to supply, by a scrupulous spiritual realism, some antidote to that glamour.

In the Days of the Comet, H. G. Wells, 1906

First published 2019

Amberley Publishing
The Hill, Stroud
Gloucestershire, GL5 4EP

www.amberley-books.com

Copyright © Mark Hunnebell, 2019

The right of Mark Hunnebell to be identified as the Author of this work has been asserted in accordance with the Copyrights, Designs and Patents Act 1988.

ISBN 978 1 4456 8447 5 (print)
ISBN 978 1 4456 8448 2 (ebook)

British Library Cataloguing in Publication Data.
A catalogue record for this book is available from the British Library.

Origination by Amberley Publishing.
Printed in Great Britain.

Contents

Introduction

The inspiration for this book originally came from an information card available for visitors to White Wells in the 1950s. The card was produced by the *Ilkley Gazette* office and provided a useful guide to some of the prominent features that could be seen in the valley from White Wells on the moors above the town.

The card was an updated edition of an earlier version dating back to the beginning of the twentieth century, when Mr Brumfitt installed a 'view station' outside White Wells in 1903.

I thought it would be of interest to contrast which features could be seen over a century ago, which could be seen in the 1950s and which have been demolished or built over the period of time since.

As information was gathered and research done, it became apparent that just a simple guide to the principal features would not be doing the subject justice and that here was an opportunity to expand a little further on the subject. I collated what I had and contacted Amberley Publishing, who had published *Ilkley and the Great War* for co-author Caroline Brown and I in 2014.

As the manuscript stood it was not possible to publish it. However, with a little modification it was deemed suitable for publication as part of Amberley's *Secret* series, profiling lesser-known aspects of local history for towns up and down the country.

As a result this book is a record of many of the developments and changes that occurred in Ilkley during the second half of the nineteenth and throughout the twentieth century, much of the information being sourced from efforts to compile an index of the *Ilkley Gazette* for my own interest in local history. Many of the articles referred to have not seen the light of day since their original publication and the details simply lost or forgotten. I am grateful that the Ilkley Library holds old copies of the local newspapers.

I sincerely hope that you enjoy this all too brief tour around some of the 'secret' aspects of Ilkley's history. It is by no means comprehensive as new information is constantly being rediscovered within the pages of the old *Gazettes*, and other items didn't make the final cut due to limitations on what could fit in a publication of this length.

It has at times been hard work compiling this book, but also enjoyable. It is wonderful when you discover a nugget of information in the pages of an old newspaper and think that very few people may be party to it – the original readership having died long ago and the piece possibly remaining unread until now.

I hope that as well as a record of some of the intriguing facets of the town, I have also inspired an interest to find out more about local history and that the thirst for this knowledge never diminishes.

Mark Hunnebell, May 2019

1. The Town

Ilkley was a small rural community for generations. There had been a Roman fort, generally believed to have been called 'Olicana', situated near to the main crossroads in the village. A church was later built on part of fort site and the village consisted of a few cottages and smallholdings.

At the beginning of the eighteenth century a cold spring on the moors was enclosed for bathing purposes. By the end of the century this was further improved with the building of two baths at White Wells in 1791. (There will be more about White Wells in chapter four.) The popularity of 'Hydropathy', taking the waters, increased during the nineteenth century.

The Ilkley Bath Charity was established in 1829 and from 1830 patients underwent treatment at the 'Charity Bath' built adjacent to White Wells.

The Ben Rhydding Hydropathic Establishment opened in 1844 above the village of Wheatley around a mile to the east of Ilkley. This was followed in 1856 with the opening of Wells House Hydro on the edge of the moor above the town. Wells House remained in use as a hotel until the Second World War, when the government's 'Wool Control' requisitioned it (along with Ben Rhydding Hydro). In the 1950s Wells House became the Ilkley College, more latterly the Bradford and Ilkley Community College, until 1999 when it was converted into sixteen apartments. Ben Rhydding Hydro was demolished in the 1950s to make way for the 'High Wheatley' houses that now stand on the site.

The Bath Charity opened its own large premises, the 'Charity Hospital', to the south of Green Lane in 1862, becoming a popular convalescent home. Before the First World War it had provided rest and recuperation for working people, many of whom were from the manufacturing towns of the West Riding. At the start of the war in 1914 it was requisitioned and became the Ilkley Auxiliary Military Hospital. Following hostilities it reverted to its civilian role as a convalescent home and remained as such until the late twentieth century. It has since been extensively refitted and is currently the Abbeyfield residential home.

Although the Charity Bath Hospital had opened in the early 1860s it catered for patients seeking rest and recuperation. By the 1880s a small cottage hospital was opened alongside the river near the cemetery. At the beginning of the twentieth century a new hospital was required, better placed to serve the needs of the increasing population. A site on Springs Lane was chosen and the foundation stone of the Coronation Hospital was laid in April 1904.

In 1915 Middleton Sanatorium, a tuberculosis isolation hospital, opened on the northern slopes of the valley. This was extended over the next decade or so, and in 1927 a nurses' hostel was built adjacent to the site (now 'Westville House School'), along with the row of white painted houses on Carters Lane for other hospital staff. The nurses' accommodation is at the bottom left of the aerial photograph dating from around 1950, which shows the sizeable extent of the sanatorium site by this time.

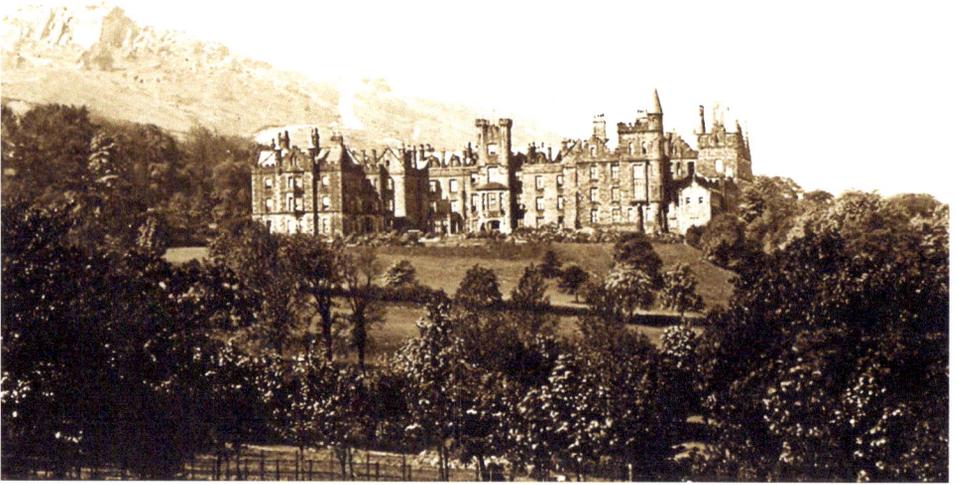

Ben Rhydding Hydropathic Establishment, with the Cow and Calf Rocks and Hangingstone Quarry access track in the background. (Sally Gunton)

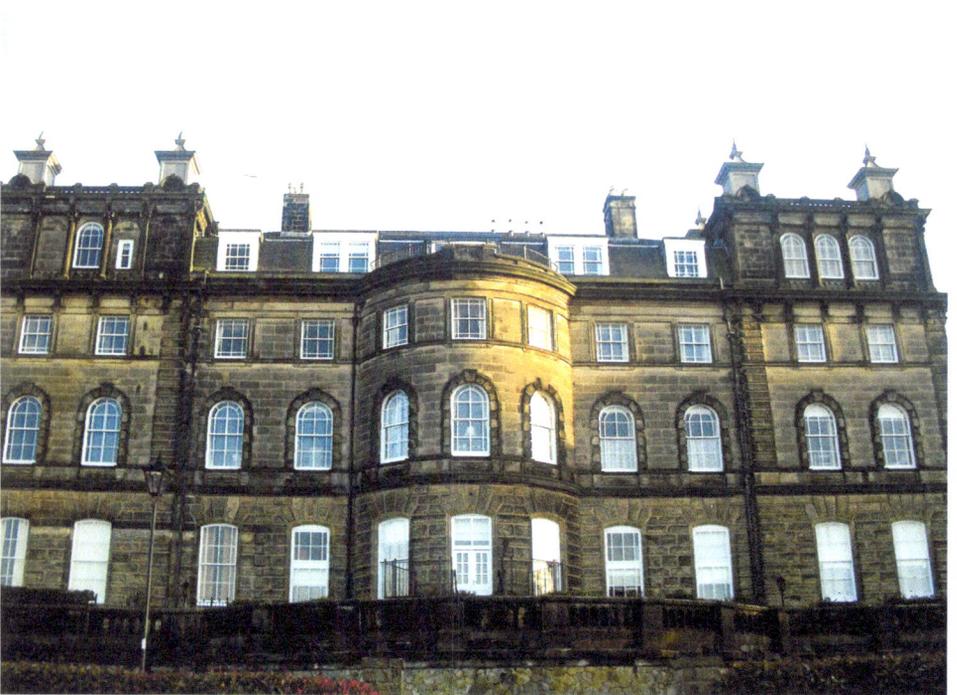

The northern elevation of Wells House. This grand building has survived two fires, one in 1908 and one in 1951; both in the north-east turret, and both quickly brought under control. (Mark Hunnebell)

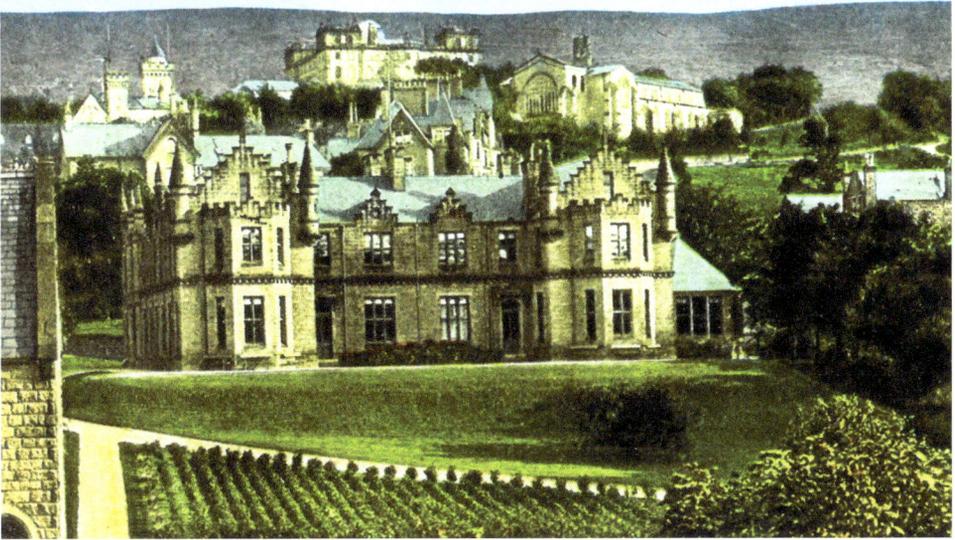

Ilkley Charity Hospital with Wells House, Ilkley College (now Deaconess Court) and St Margaret's Church in the background. (Sally Gunton)

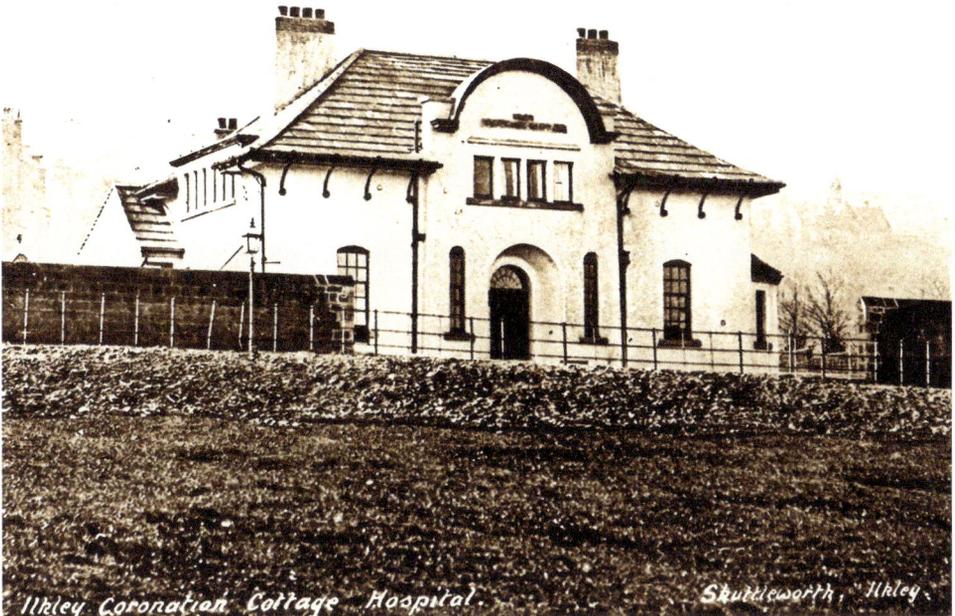

The Coronation Hospital, belatedly celebrating the coronation of Edward VII, opened in April 1905. The hospital was extended during the course of the twentieth century. One of the first patients received at the Coronation was a workman involved in an accident at the construction and demolition site of the new and old Star pubs. (Sally Gunton)

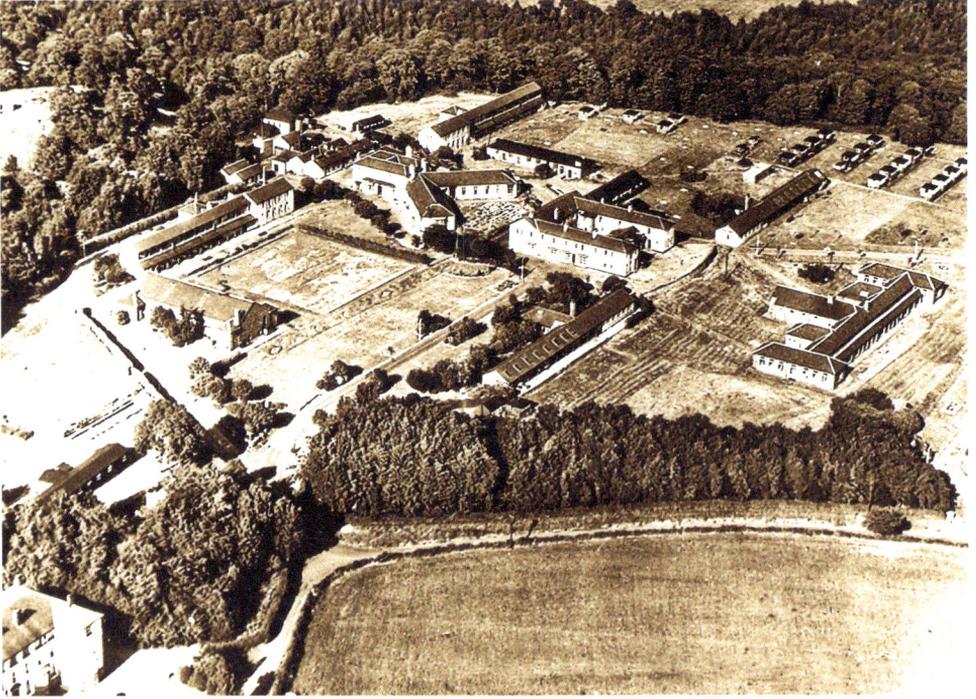

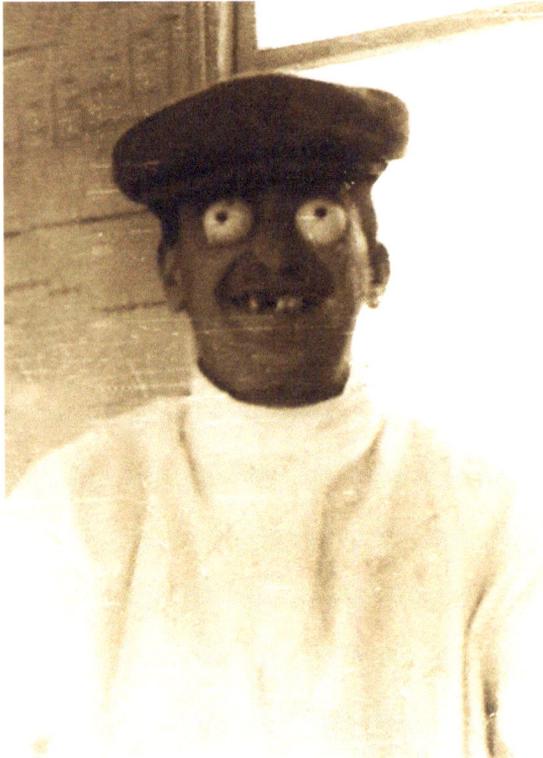

Above: Middleton Sanatorium from the air. (Sally Gunton)

Left: 'While the Matron's Away...' The serious business of fighting TB was improving with the development of antibiotic drugs in the late 1940s, and patient morale at Middleton Sanatorium was kept up with a little light relief provided by the staff too, especially at Christmas, as demonstrated in this photo of part-time ward orderly Edwin Hunnebell, taken in 1949. (Mark Hunnebell)

As the number of TB cases declined Middleton Sanatorium gradually evolved into a geriatric care hospital and eventually closed in 1990. The site was cleared except for parts of the former staff social club, which remains derelict. Plans for the redevelopment of the site keep stalling.

DID YOU KNOW?
In the late 1930s proposals were made to relocate the Coronation Hospital to a new building on fields in Ben Rhydding adjacent to Wheatley Avenue on the eastern approach to the town. Here is an artist's impression of the proposed 'New' Coronation Hospital from 1937. Plans were abandoned at the start of the Second World War in 1939 and not revived afterwards when the NHS was created in 1948.

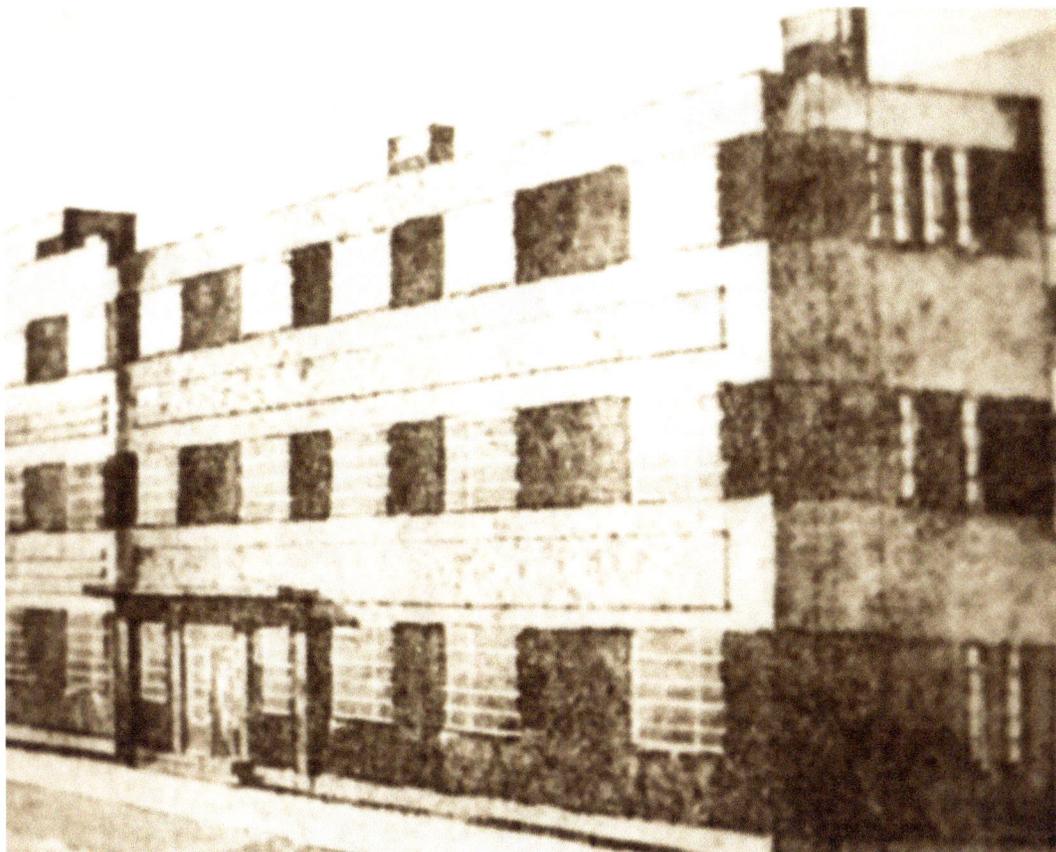

Proposed new hospital. (*Ilkley Gazette*)

The Coronation and Middleton hospitals continued to serve the area for much of the twentieth century. After the Second World War a former YMCA hut was moved from Easby Drive in 1946 on to part of the town's central car park to serve as a children's clinic, while many of the town's doctors continued to hold surgeries in their homes until 1968 when a purpose-built health centre was opened on Springs Lane adjacent to the Coronation Hospital to centralise local healthcare services. This was rebuilt in 2001 and continues to cater for the town's medical requirements.

The Railway

One of the most significant developments in the town was the arrival of the railway in 1865. This connected Ilkley to Otley, Leeds and Bradford. Though the route from Bradford was via Apperley Bridge until 1876 when the line extension from Shipley to Guiseley via Baildon was opened.

In the 1870s there were proposals to extend the railway to Skipton. This would require a bridge across Brook Street to carry the line. In 1874 a mock-up was erected across the street. It caused a strong reaction from those concerned that it would be an eyesore. Despite this, a decade later plans were more advanced and became a reality. A bridge was erected, along with a viaduct carrying the railway over the western portion of Ilkley.

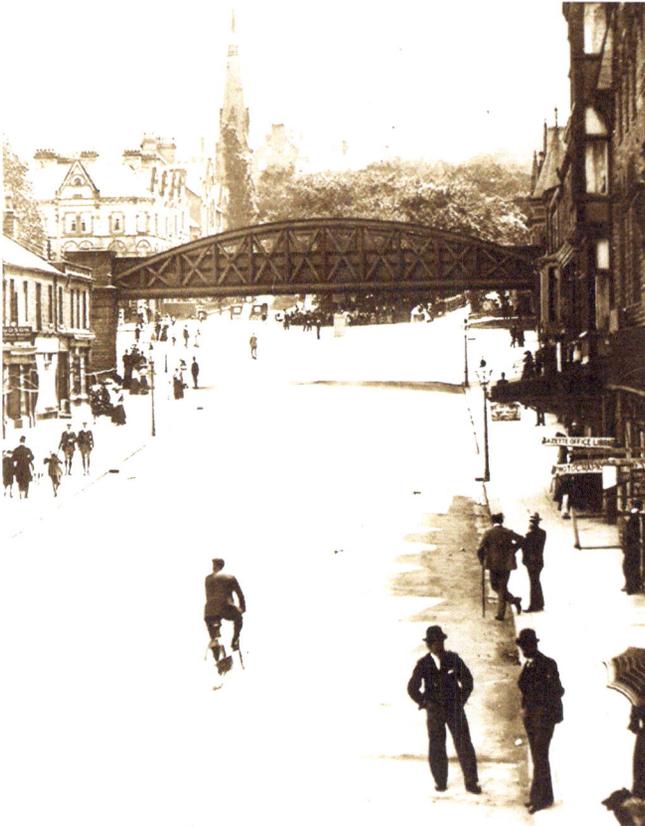

Brook Street Railway Bridge, with the spire of the Wells Road Methodist Church on Wells Road and White Wells on the moors in the background. (Sally Gunton)

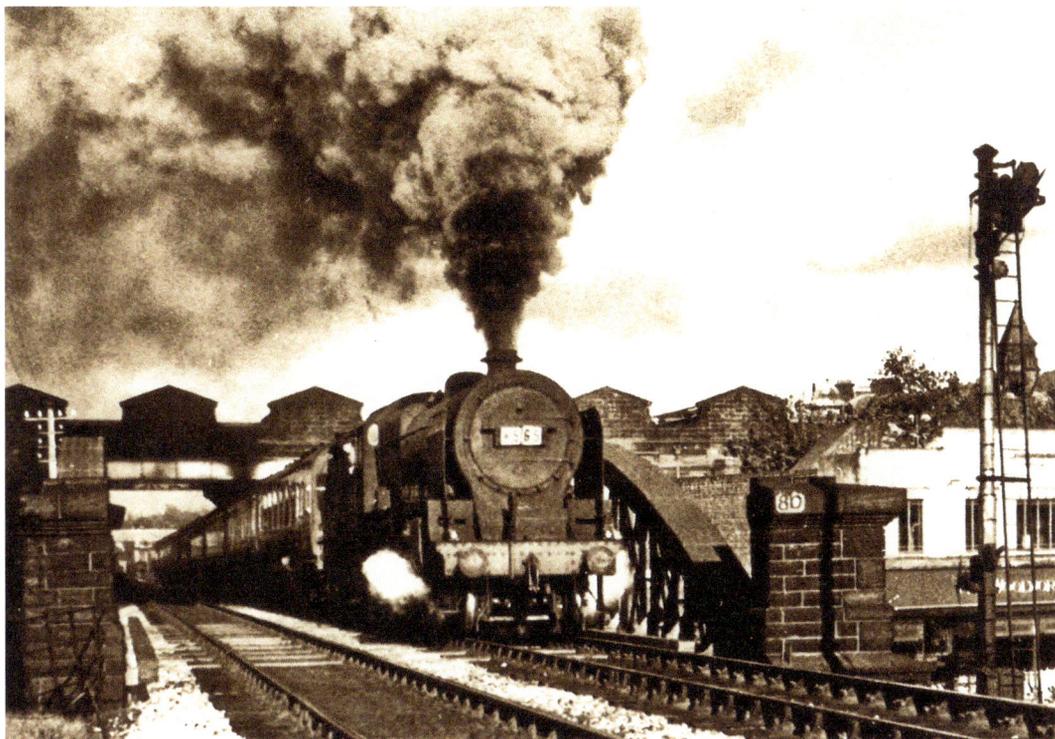

You can almost hear the mighty huff of this steam locomotive as it builds up speed passing out of Ilkley station, across the bridge and away up the valley towards Addingham. Woolworths store can be seen down in Brook Street to the right of the photograph, and above the Town Hall clock tower is partially obscured by the signal post. (Sally Gunton)

The bridge dominated Brook Street for almost eighty years from the opening of the Skipton extension in 1888 until 1966 when it was removed following the closure of the line the previous year as part of the Beeching Report. By the time of its demolition in July 1966, many were lamenting its demise and the loss of the railway link to Skipton.

When the railway was extended in the 1880s houses in Yewbank Terrace were demolished to make way for the viaduct that carried the line to pass through. The 1960s closures determined that the railway connections to all points west of Ilkley should be severed as well as those linking Ilkley with Otley and Harrogate. Fortunately the lines connecting Ilkley to Leeds and Bradford were retained. During the 1990s these lines were adapted to accommodate electric trains. The tracks to the west of Ilkley were removed in the late 1960s and the viaduct demolished in the early 1970s. Much of the land the railway crossed in the Victoria Avenue area is now occupied by housing.

A sizable area adjacent to the railway station, previously occupied by an engine shed, coal drops and goods sidings, was developed over a number of years. This became car parking space, flower beds and the bus station. In 1983 Hillards supermarket moved from Railway Road to new premises on Springs Lane, built on part of the former goods yard. In 1987 Hillards sold out to Tesco, which has occupied the site since.

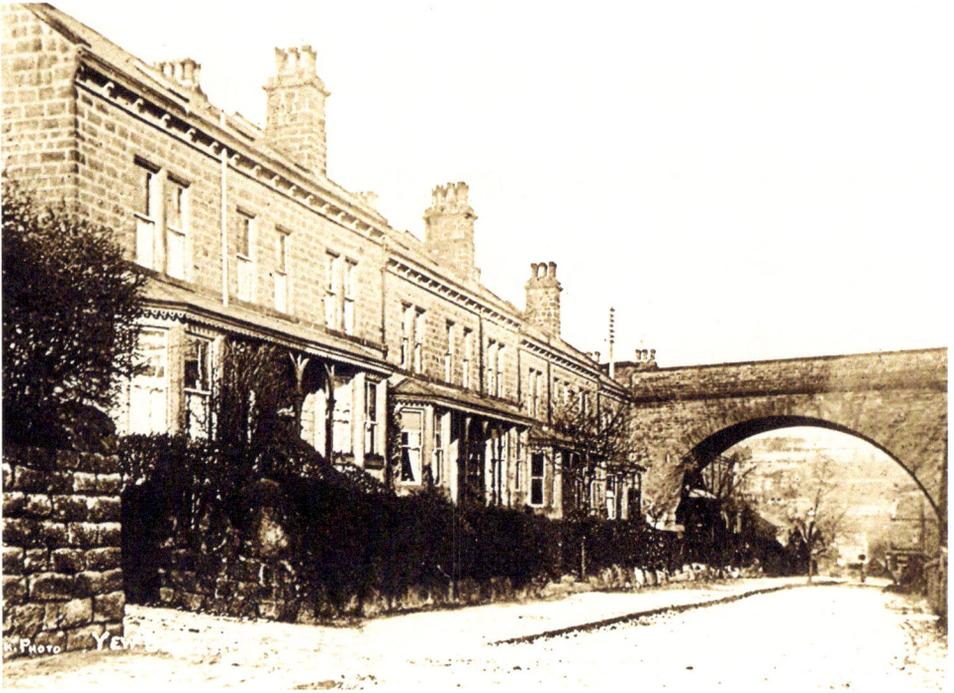

The railway viaduct traversing Yewbank Terrace. (Sally Gunton)

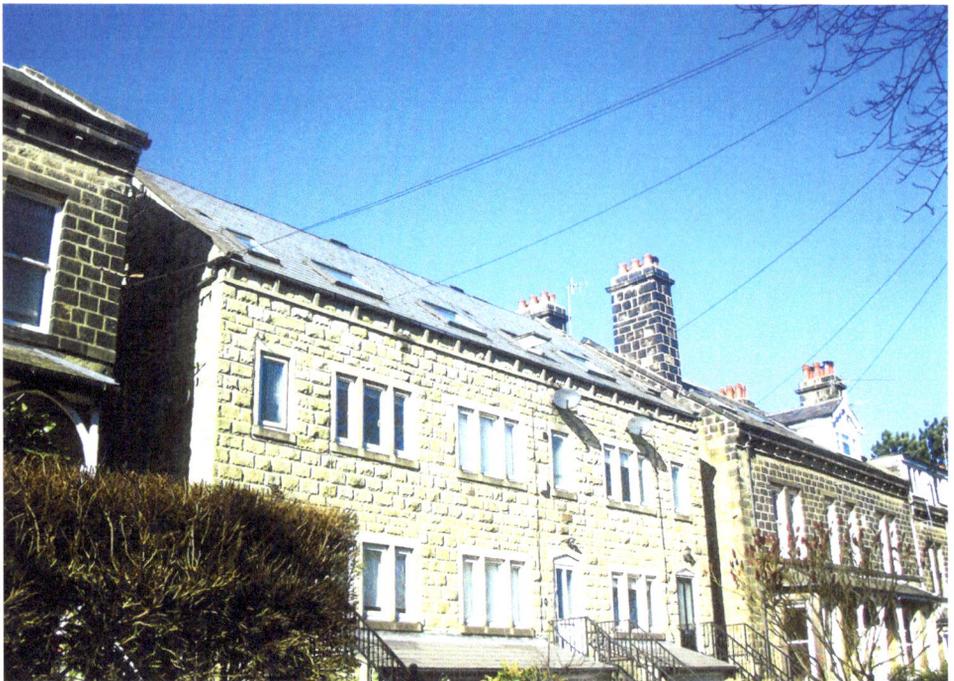

Houses were later rebuilt in the gap left by the removal of the viaduct. (Mark Hunnebell)

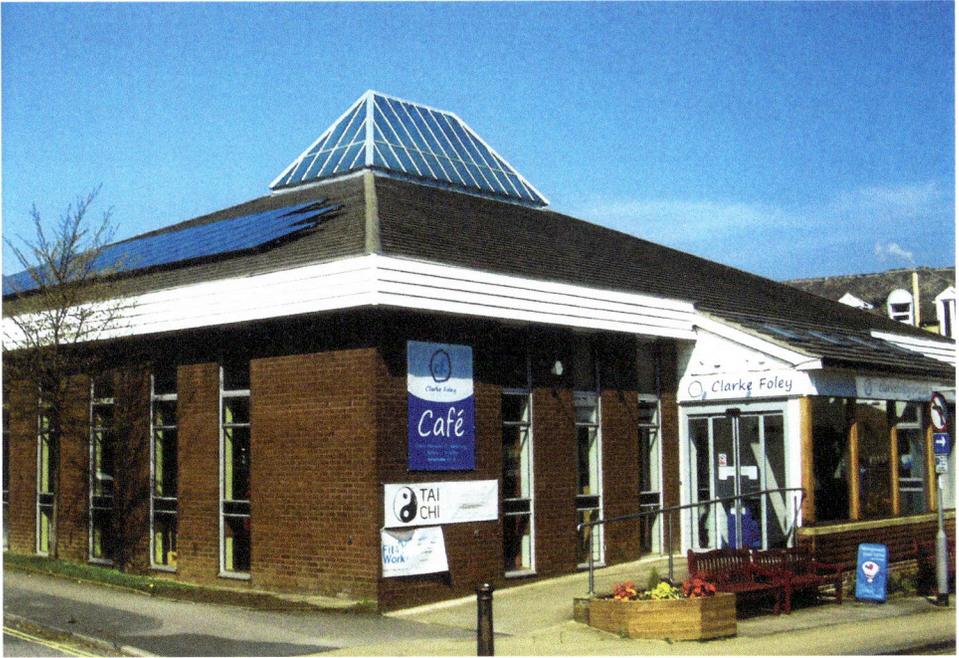

The Clarke Foley Centre opened in 1981 on land previously occupied by part of the viaduct, and before the viaduct by Ilkley's first roller-skating rink in 1876. (Mark Hunnebell)

Between 1986 and 1989 Ilkley railway station was extensively redeveloped and new shops built. This photograph looks through the gap towards Brook Street where the former Skipton line left the station to cross the bridge. The gap was modified to form the outer wall of what is currently Marks & Spencer's food hall warehouse. Deliveries now arrive through here instead of trains! (Sally Gunton)

Other Developments in the Town

The 1860s saw significant tracts of land sold off at auction for building development. The former Green Lane became The Grove. The cottage in the photograph stood towards the eastern end of Green Lane, roughly opposite the bottom of Riddings Road.

The Grove Hotel was built during the 1860s and the Congregational Church, with its graceful spire, in 1869.

The Ilkley Local Board was formed in 1869 and oversaw many of the developments in the town over the course of the following decades. The population of Ilkley increased from 1,043 in 1861 to 2,511 by 1871.

Green Lane Cottage, Ilkley, 1867.

Shuttleworth, Ilkle

Green Lane, now the Grove. (Sally Gunton)

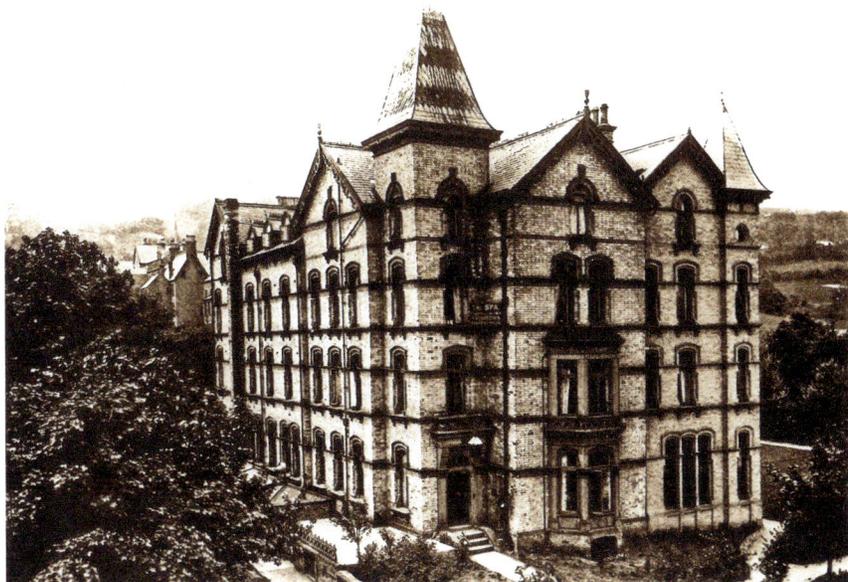

The former Grove, later renamed Spa Hotel, eventually became flats. It was demolished in 1989 and replaced with a modern building. The Spa was also home to the Bluebird Café from 1930. (Sally Gunton)

The former Congregational Church on the Grove. Following extensive restoration and an amalgamation between the United Reformed Church and the Methodists, Christchurch reopened in time for Christmas 1985. (Mark Hunnebell)

When All Saints School moved to Skipton Road in 2003 the former upper school was converted to residential use, while the infant's school building further along Leeds Road was demolished and housing built on the site. (Mark Hunnebell)

In 1872 a national school was opened on Leeds Road to cater for the educational needs of the increasing numbers of children in the town. The Ilkley Grammar School moved into purpose-built premises on Cowpasture Road in 1893.

The Ilkley Orphanage, a privately run institution for girls, was opened by Mr Conyers in 1881 at Wharfedale Grange Farm, Ben Rhydding. Within a few years it became desirable to move the orphanage into the town. A property in Richmond Place was taken and the move made in 1884. Another move occurred in June 1888 when the establishment relocated to Wharfe View Road and larger premises.

Although Mr Conyers died in March 1907, the orphanage continued in use until 1921. The *Ilkley Gazette* reported in April 1921: 'The difficulty of upkeep remained, however, together with the fact that the committee were having so few applications for admission... on 14th January, it was decided to wind up the institution...'

The property was sold at an auction held in the Crescent Hotel in February 1922 to Mr Gee for the sum of £1,000. In August 1922 the Moorside Hand Laundry, a somewhat small-scale business previously operating in Leeds Road, moved into part of the former orphanage. By the 1930s the building was in use as Mr Gee's family home. The building survives, having been converted into flats in the early 1970s.

During the 1890s the Ilkley Local Board undertook further improvements in the town. These included taking over the production of the town's gas supply, a works depot, a fire station and an abattoir. The abattoir provided a single and more hygienic facility for local meat production as an alternative to the many small slaughterhouses in outbuildings behind butchers' shops in the town centre, the unpleasant associations of which had not gone unnoticed and was (understandably!) considered detrimental to the promotion of Ilkley as a pleasant place to visit.

The former orphanage, Wharfe View Road. (Mark Hunnebell)

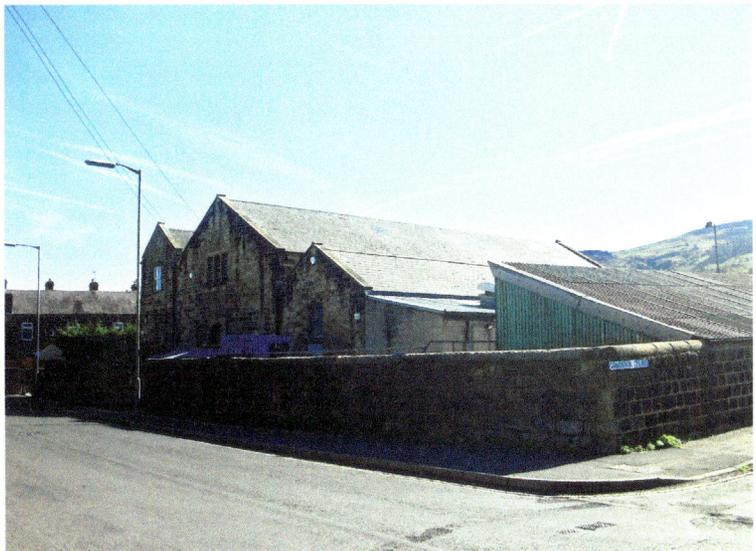

Ilkley Abattoir. (Mark Hunnebell)

In the 1890s a new fire station replaced the earlier one located behind the old Star pub. The Golden Butts Road station featured a prominent tower that is still standing. The building was extended in the 1920s to accommodate motorised fire engines. The fire service moved again in 1974 to a new station on Little Lane. (Mark Hunnebell)

Into the Twentieth Century

Housing developments continued around the turn of the century, with the creation of Trafalgar Road, Nile Road and Victory Road being built on the cricket pitch between Brook Street and Nelson Road. Large properties were also built in other areas of the town and road improvements were undertaken too.

Standing on Leeds Road opposite the Crescent Hotel, two old pubs were demolished in 1904 and 1905. Firstly the Wharfedale Inn was replaced with the new Star pub and once this was open, the old Star was demolished. This improved the line of the road from Leeds Road into Church Street by removing a sharp dog-leg. Towards the river New Brook Street was created and the improvements culminated with the completion of the New Bridge in 1906, opening up the north side of the river for housing development.

Shortly after these developments further construction took place on Station Road. For some time the council had contemplated a town hall and other public buildings. The resulting complex variously opened over a number of years, with the library first in 1907. One of the town's most famous former residents, Revd Dr Robert Collyer, visited Ilkley from the USA for the event held on 5 October. The following year the Town Hall opened. Although the clock had been illuminated since December 1907, there were concerns that the electric light generated in the Town Hall was too bright to be able to see the time clearly. The adjacent King's Hall also opened in 1908 and provided a suitable venue for public meetings, theatrical productions and the growing fascination with the new technology of the moving picture – 'cinematography'.

Among the many houses built during the 1900s was Heathcote, designed by Edwin Lutyens, on Grove Road. (Mark Hunnebell)

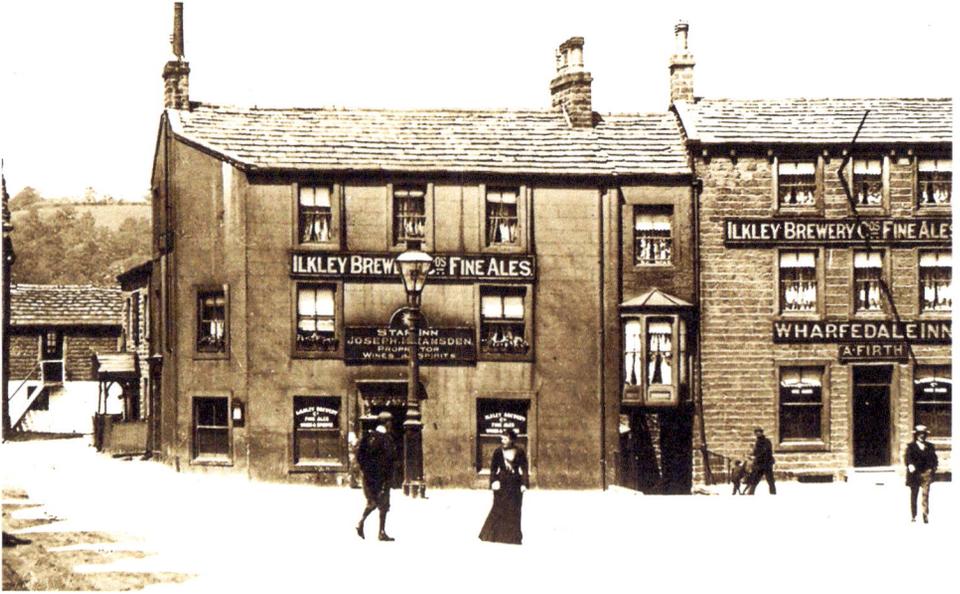

The old Star and Wharfedale pubs. (Sally Gunton)

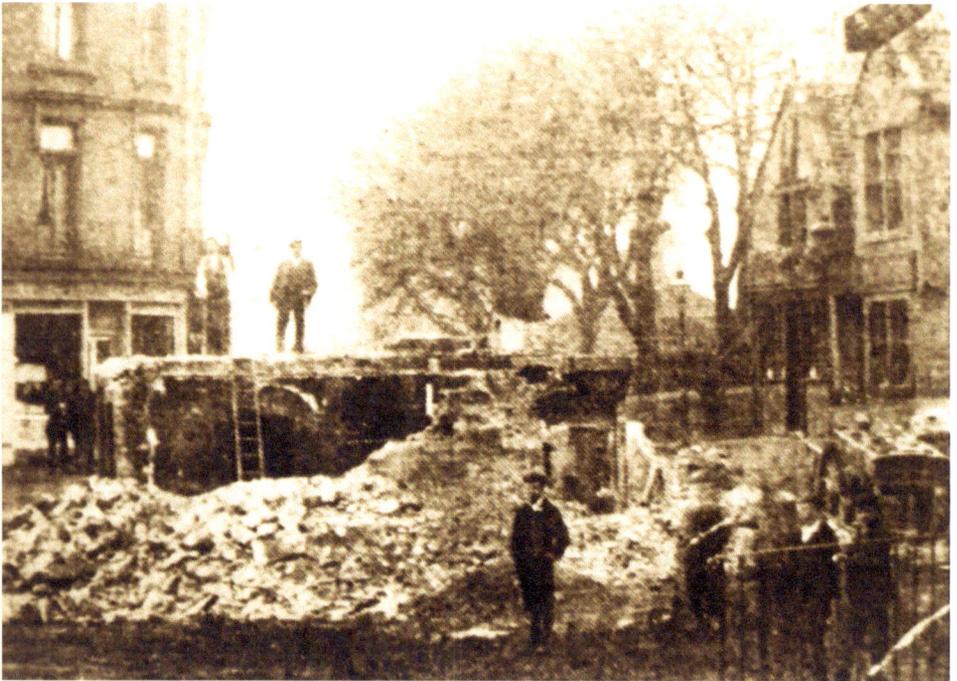

Demolition of the old Star pub. (*Ilkley Gazette*)

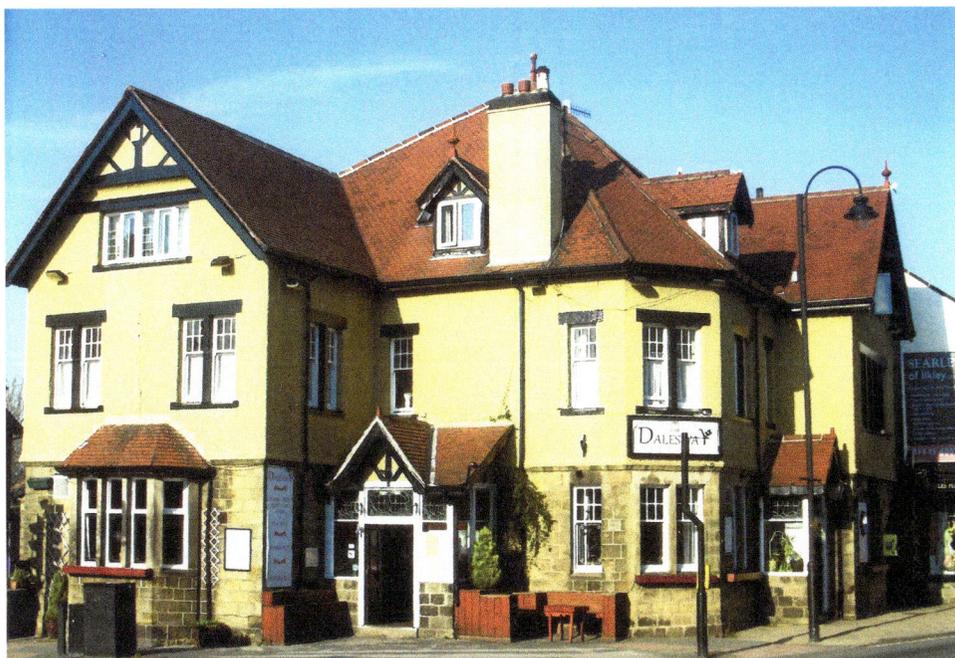

A familiar landmark in the centre of Ilkley, the Star changed its name to the Dalesway Hotel in 2009. (Mark Hunnebell)

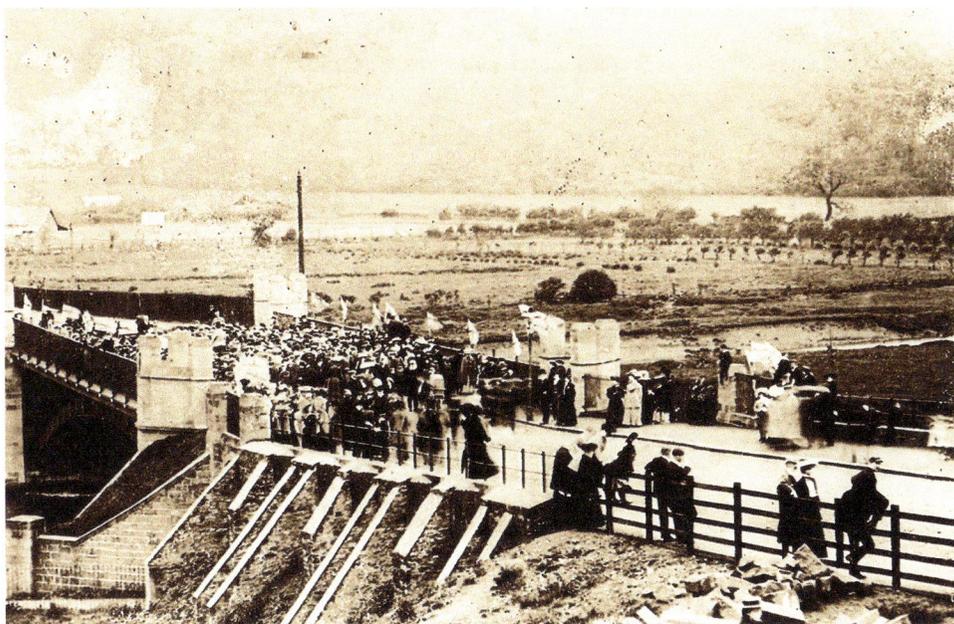

The New Bridge was officially opened on 2 June 1906, the event coinciding with the arrival of the 3rd Royal Lancashire Engineer Volunteers. The soldiers marched from the railway station and over the bridge to their annual camp, thus making the first 'official' crossing... (Sally Gunton)

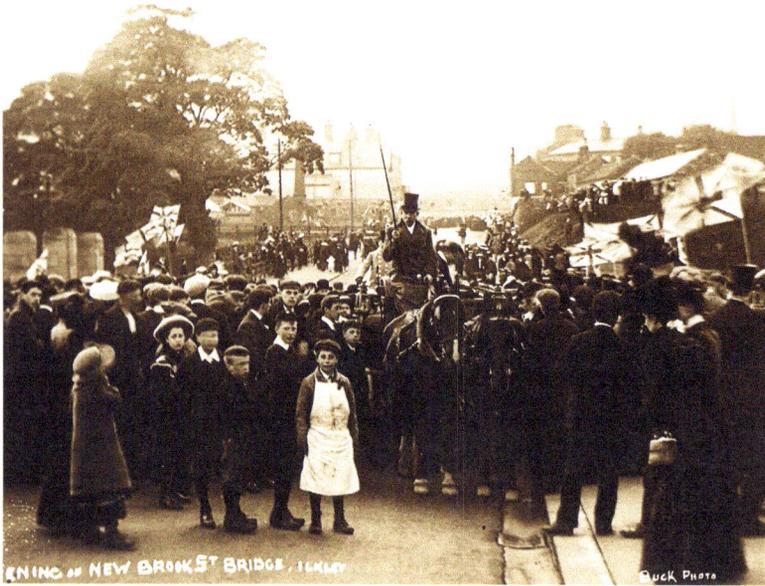

...Much to the delight (or not, looking at the sullen expressions) of the crowd that had turned out for the event. (Sally Gunton)

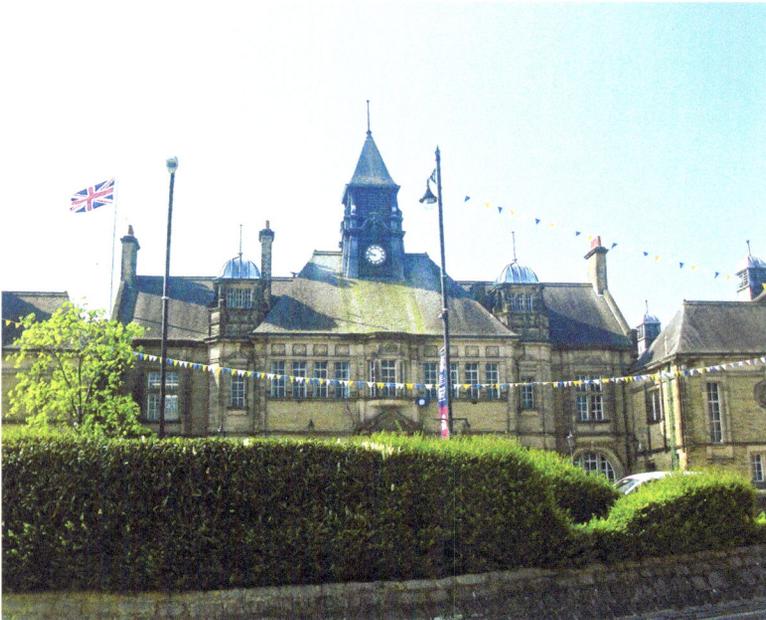

Ilkley Town Hall. (Mark Hunnebell)

A few years later the Winter Gardens was built on to the west side of the King's Hall and opened in 1914, coinciding with the official birthday celebrations of George V in June.

The post office moved from Wells Road to Chantry Drive in 1913, where it remained until 1990 before moving into the redeveloped railway station. The sorting office moved to a building to the rear of Chantry Drive, accessed from Cowpasture Road.

Former Council meeting rooms, the Grove. (Mark Hunnebell)

The post office on Wells Road. Before the town's development, the post office had previously been on what is today Skipton Road, and before that, Green Lane. (Sally Gunton)

The former post office, Chantry Drive. (Mark Hunnebell)

Public buildings and some private houses in the town generated their own electricity in the early years of the twentieth century. The council sought to build an electricity works to provide a public supply. The issue was debated several times and eventually the necessary loans were secured and the works opened on Little Lane in 1915. Construction had started in October 1914, despite the outbreak of war in August. The council answered critics by stating that the electricity undertaking had been in hand prior to the war and to leave it unfinished would result in still having to repay the loan and interest thereon – and, crucially, no electricity.

By the 1920s more houses in the town were being connected to the electricity supply. A showroom was opened in 1927 by the council in Chantry Drive, enabling the latest appliances to be displayed, and promoting the benefits to those considering subscribing. For others though, gas was the main source of light until the 1930s – particularly in the Wellington Road area, ironically closest to the electricity works. For many, elbow grease was the main form of power for washing and cleaning!

The council's involvement in the town's supply ended in 1948 when the Yorkshire Electricity Board was created and centralised production made the works redundant. The building survives today as a motor garage and offices of New Zealand Wool, which has added an extension to the north side of the original building.

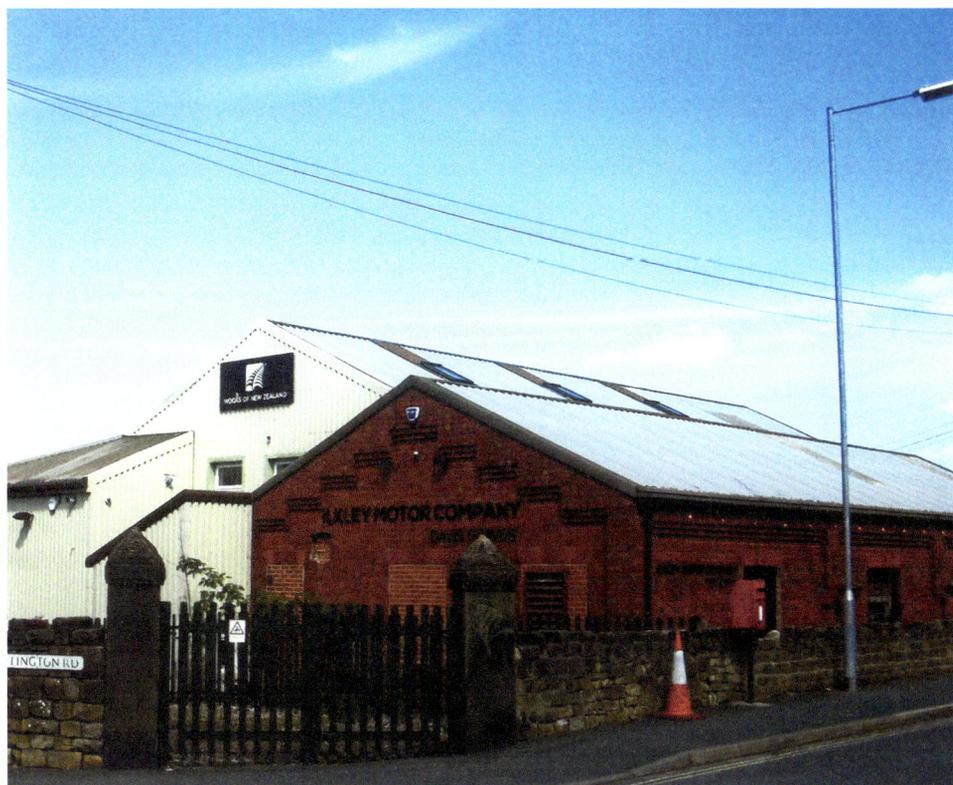

Part of the former red-brick electricity works. (Mark Hunnebell)

The former electricity showroom, Chantry Drive. (Mark Hunnebell)

Improvements in the production of gas were made with a large new retort house at the gasworks in 1935. The new structure provided a prominent, if not so much visually appealing, landmark until it was demolished in 1965. At the time of its construction it was described as 'handsome'. It is interesting to speculate what the reaction would be if a similar structure was built today!

The gasworks site was redeveloped in the 1990s to make way for Booths supermarket.

DID YOU KNOW?
The retort house built at the gasworks in 1935 was designed by Fredrick Charlton. He also designed the Church of St Philip at Osmondthorpe, Leeds (built between 1929 and 1934), and the Christian Science Church on Wells Road, Ilkley (1939–41), and Rawdon Crematorium in the 1950s.

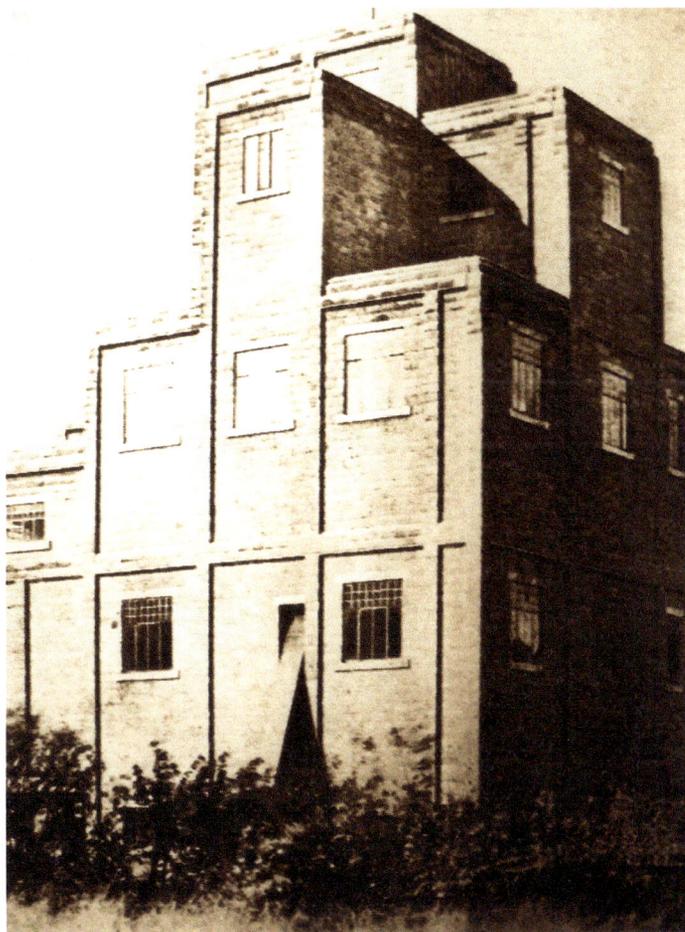

The gasworks
retort house, 1935.
(*Ilkley Gazette*)

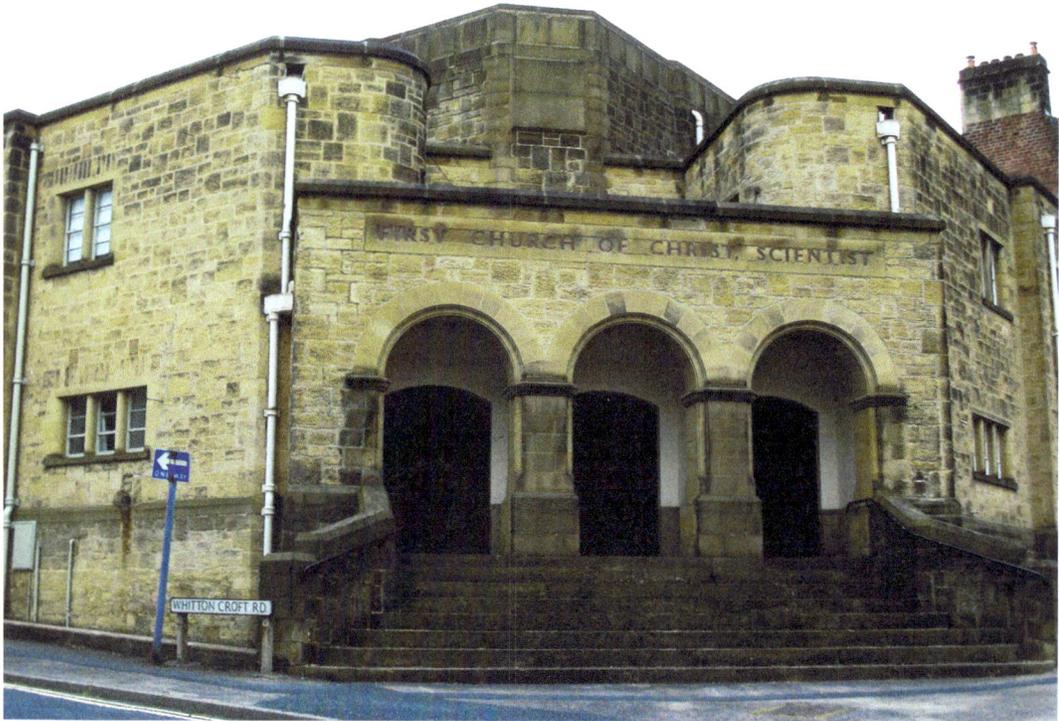

The former Christian Science Church, now Wells Road Business Centre. (Mark Hunnebell)

Public Housing

Following the 'Great War', the government encouraged a policy to stimulate the economy by building houses. In 1919 the council discussed the proposals and as a result the houses of Colbert Avenue, The Crescent, Wyvil Road, Wyvil Crescent, River View and Collyer View were built in the early 1920s. After the Second World War another housing programme was undertaken. The linking up of Little Lane and Valley Drive was completed in 1946 and land adjacent used for housing. The streets of Mayfield Avenue, Woodlands and Hampshire Close were built.

DID YOU KNOW?
At the turn of the nineteenth century Little Lane was in such a poor state of repair that in was referred to as 'Mucky Loin'. When the road was made up the local paper praised the improvement in 1901: 'However well-deserved this appellation in the past, Little Lane is Mucky Loin no longer, for a better or more up to date thoroughfare than this now is exists nowhere in the township...'

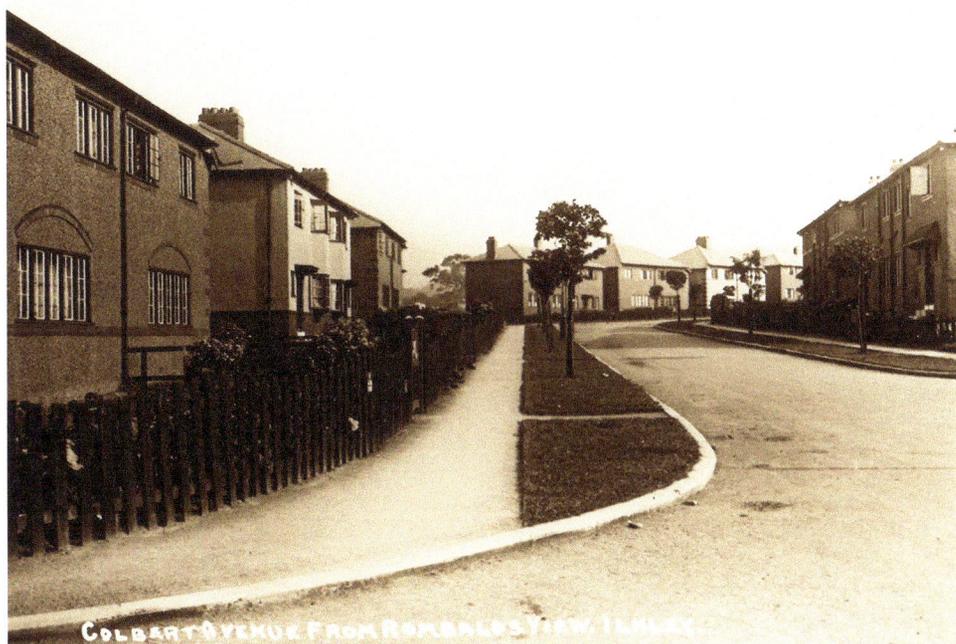

Colbert Avenue. (Sally Gunton)

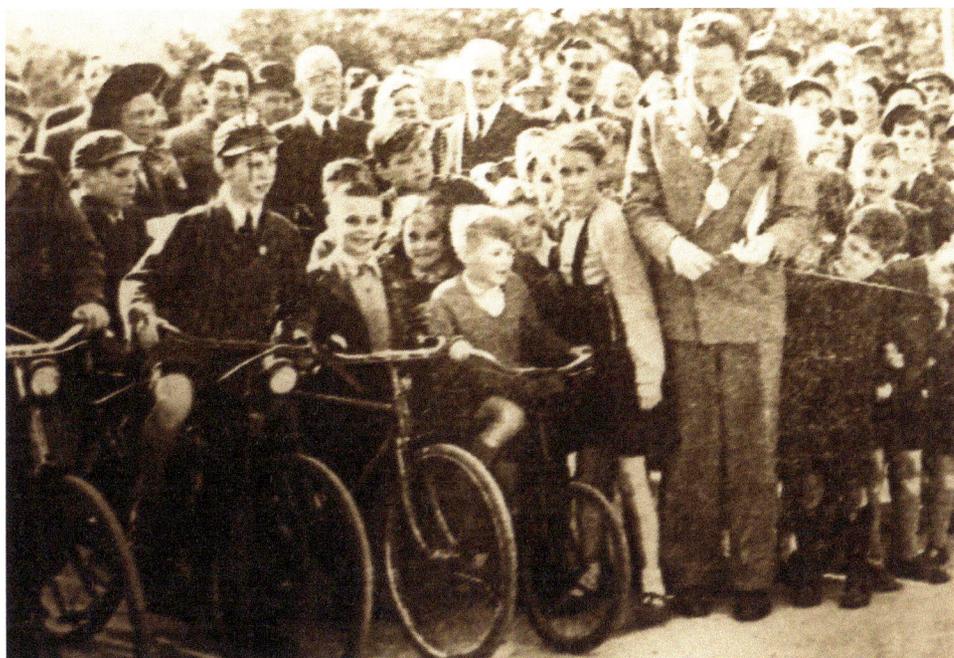

Schoolchildren jockey for position as they aim to be first to cycle over the length of the new section of road. The ribbon to open the Little Lane and Valley Drive link was cut by Mr J. R. Phillips, chairman of Ilkley Council, on 23 May 1946. (*Ilkley Gazette*)

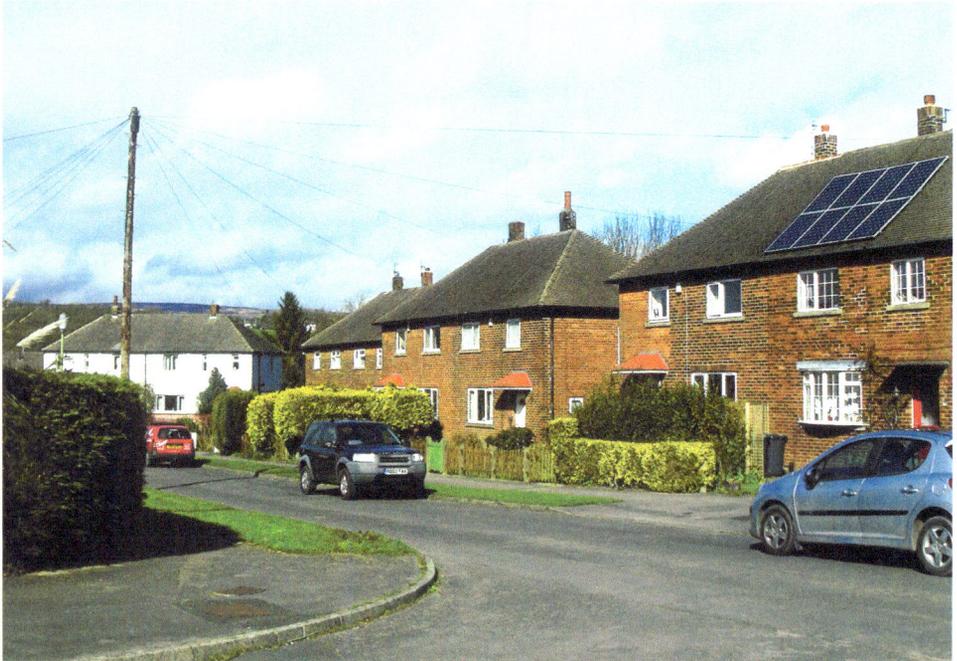

When construction of the new council estate started in 1946, private car ownership was considerably less than what it is today and solar panels were some way in the future! Pictured here is present-day Hampshire Close. (Mark Hunnebell)

Further housing developments took place into the 1950s with the building of houses on the former PSA/Salvation Army Hall site on North Parade. And in 1963 a house at the top of Brewery Road was demolished to create a new section of highway called Mayfield Road linking Little Lane with Railway Road.

The Royal Hotel, dating from 1870 on Wells Road, was demolished in 1962, replaced with the Wells Court flats development designed by C. D. Biggin. It was an era that saw many 'old' buildings demolished and replaced with modern ones without the level of planning consideration required today. Although the flats are a product of their time and by virtue an interesting feature reflecting mid-twentieth-century architecture, it is highly unlikely that a similar structure would be built in Ilkley today.

A decade on from the construction of Wells Court, the Goodwood flats were built to the north of the river and reflect the aspirations of the 1970s. In 1972 the properties were advertised with a price tag of £17,950 – rising to £23,950 for those with a swimming pool.

In 1961 the redevelopment of the manor house was completed by its owner Percy Dalton. Also formerly known 'The Castle', the building has a long past with many details of its history and evolution still unclear. The property had been in use as cottages for many years when Percy Dalton bought the site in 1942 and in the 1950s contemplated redevelopment into a singular building when the cottages were deemed unfit for habitation. One of the cottages was demolished and the remaining ones 'knocked through' to facilitate the plans. The Manor House Museum opened in 1961.

The demolition of the end house in the terrace of Brewery Road enabled the Mayfield Road link to be created from Railway Road to Little Lane in 1963. (Mark Hunnebell)

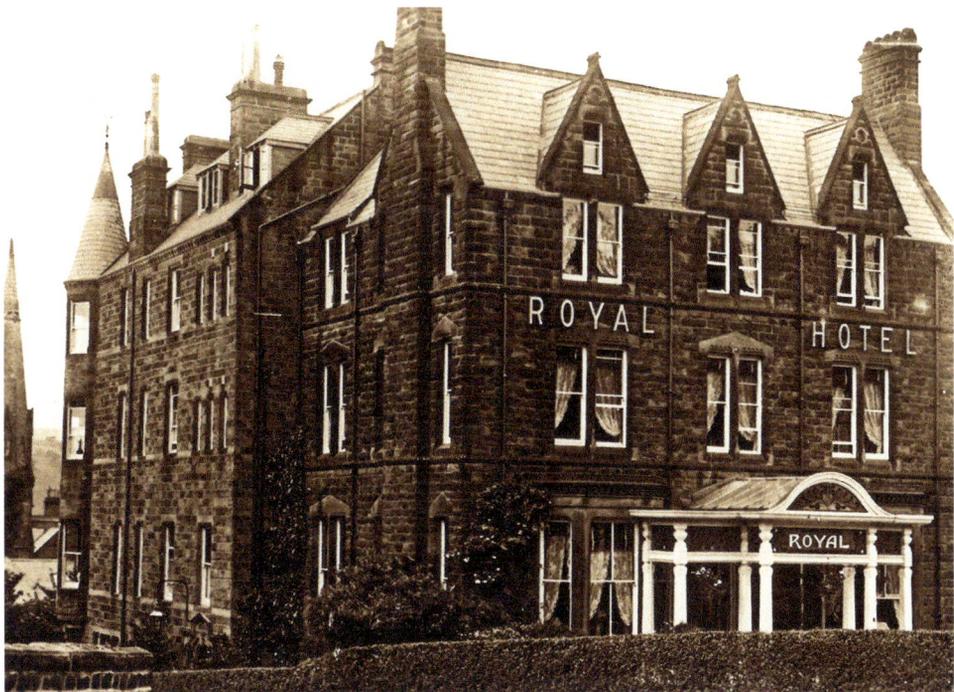

The Royal Hotel. On the extreme left is the spire of the Wells Road Methodist Church. This was demolished in 1970. (Sally Gunton)

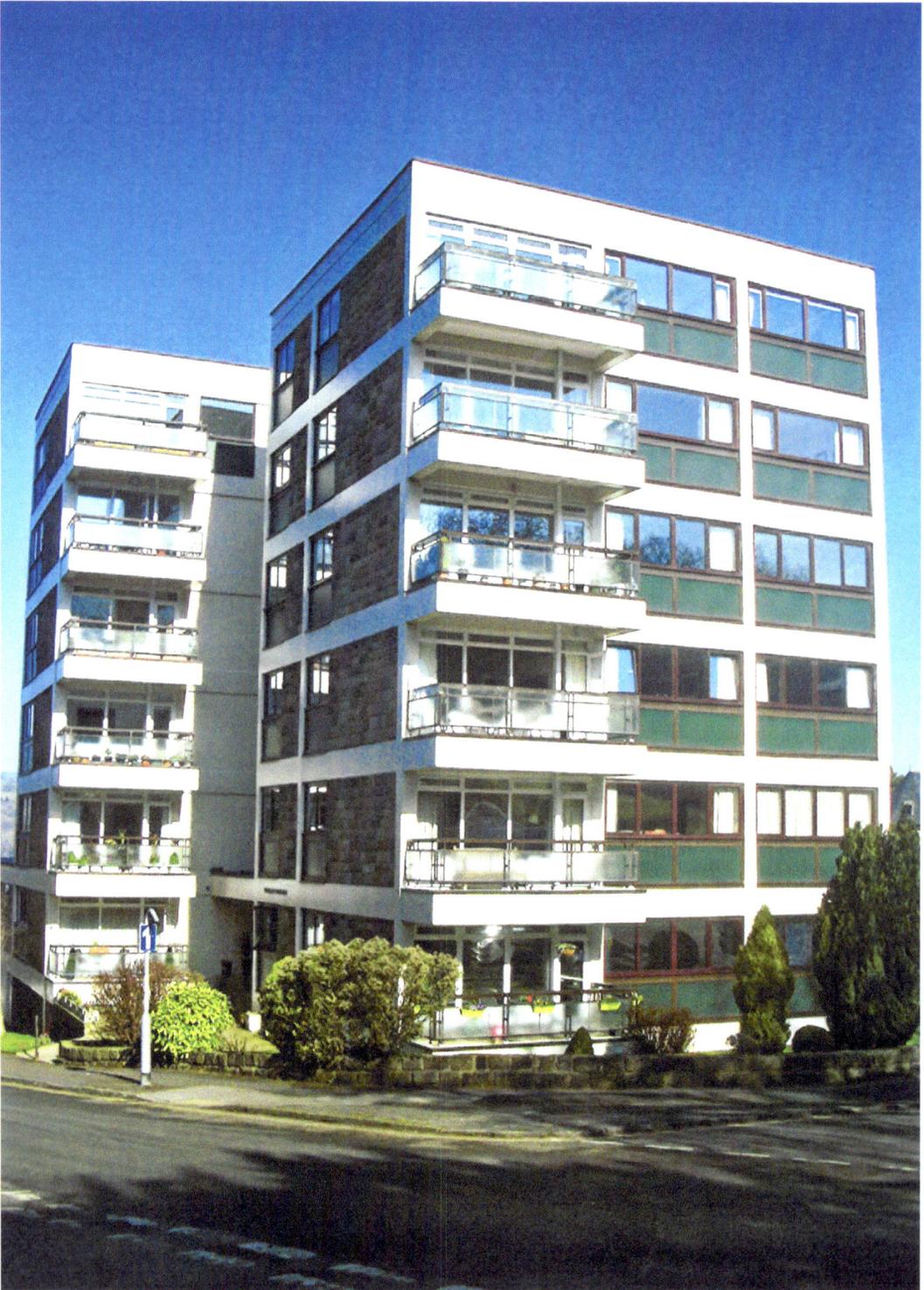

Wells Court flats. (Mark Hunnebell)

As the 1960s advanced, other developments took place. The International Wool Secretariat was built on the Ilkley Grammar School's former playing field and became an important employer in the town when it opened in 1968. As well as offices, the modern building included a lecture theatre above the main entrance foyer. The exterior features a sculpture called *The Story of Wool*, designed by William Mitchell – more latterly known for the Dodi and Diana memorial installed in Harrods.

One of Ilkley's landmarks was destroyed by fire in 1968. Opened as the Middelton Hotel in 1876, it provided fine accommodation for more than ninety years. In 1946 the name was changed to the Ilkley Moor Hotel. There was a small fire in 1947 but the main building was later gutted by fire in July 1968 and damaged beyond repair. The ruins were demolished shortly afterwards and the land at the top of Stockeld Road remained empty. In the 1970s the site was redeveloped and flats built. The surviving Ilkley Moor Vaults adjacent was the public bar of the hotel.

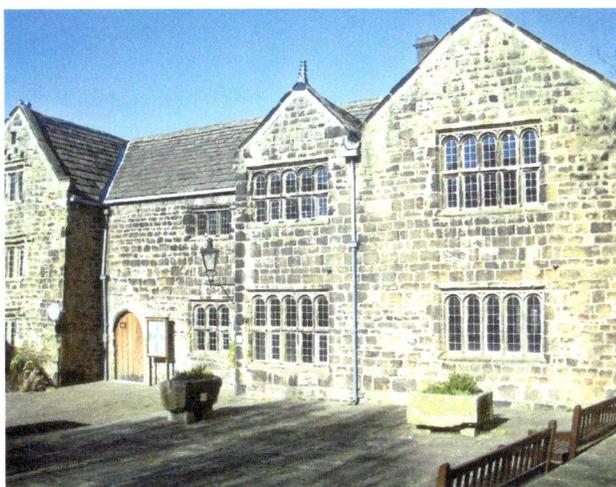

The *Ilkley Gazette* printed an article in January 1922 titled 'The Manor House as a Museum', outlining a report by architect Sidney Kitson looking into proposals for the necessary work. Although the Ilkley Council deferred the matter at the time, the plans Mr Kitson suggested appear to have largely been adopted, though with some additional modification, when the conversion was finally undertaken almost forty years later. (Mark Hunnebell)

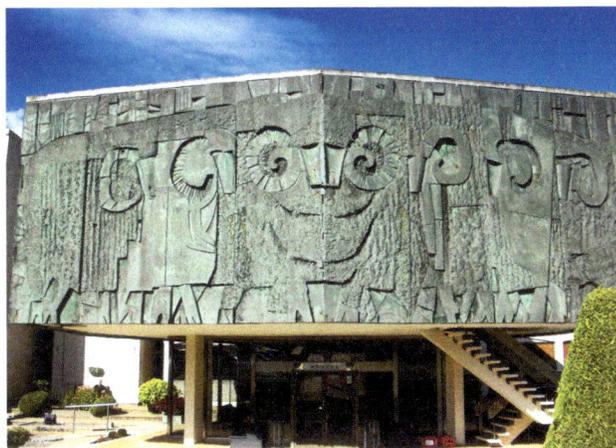

The frontage of the former International Wool Secretariat, Valley Drive. (Mark Hunnebell)

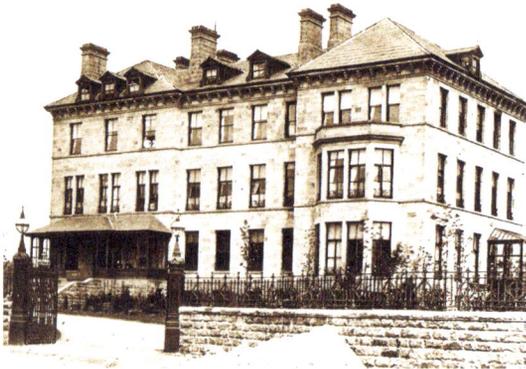

The Middelton Hotel, later renamed the Ilkley Moor in 1946. (Sally Gunton)

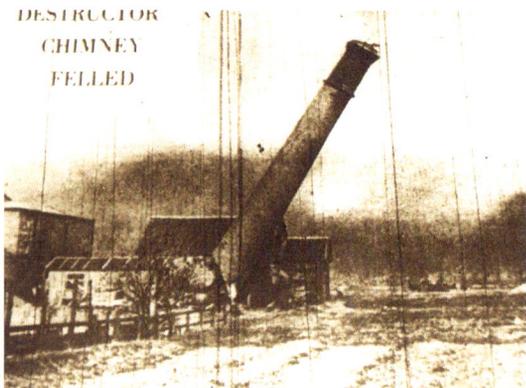

Demolition of the refuse destructor chimney. (*Ilkley Gazette*)

DID YOU KNOW?
In 1905 Ilkley Council, after some debate, built a refuse destructor adjacent to the sewage works. The destructor was in use until the Second World War, then redundant for around twenty years until its demolition in March 1961 when the *Ilkley Gazette* managed to capture this image just at the critical moment of the chimney's demise. Unfortunately the only image I have managed to find is of poor quality, being reproduced from the microfiche copy available in the library archives.

DID YOU KNOW?
In 1967 Ilkley Council debated buying a computer for the sum of £17,000. How things have changed and computer technology improved. It is unlikely the town council would consider spending £17,000 on a computer at today's values!

2. Entertainment

The large hydropathic establishments often held their own entertainment for guests. Musical evenings were a welcome diversion to some of the austere treatments undergone by guests. Prior to the 1870s entertainment among the residents of Ilkley was confined mostly to the public houses.

One of the oldest pubs in Ilkley was the Wheatsheaf Hotel in the town centre. This had a sizeable meeting room at the rear where parties, concerts and public meetings could also be held. In 1873 the Wheatsheaf's name was changed to the Albion Hotel, though this was relatively short-lived and it reverted back to being the Wheatsheaf in 1879.

DID YOU KNOW?
At the time the railway was under construction, the now demolished Grange (after which Grange estate is named), was 'made into a public-house called the Queen Hotel; and besides being well patronised by the navvies it became a favourite place for Burley people on the Sunday; just being outside the three mile radius...' However, it was converted back into a private house within two years due to 'family reasons'.

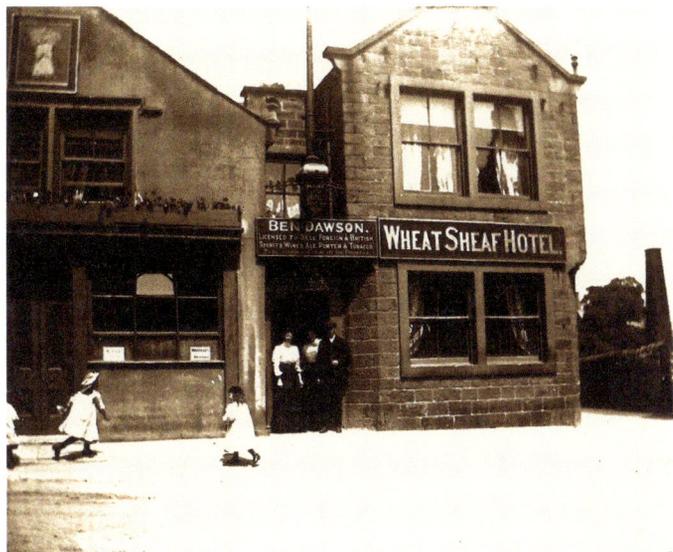

The Wheatsheaf Hotel. Note the former gasworks chimney on the right of the photo, behind the old Star pub. (Sally Gunton)

For many years Ilkley Feast, traditionally held over the first week starting after 14 September, had attractions on the land adjacent to the rear of the Wheatsheaf, courting controversy as late as 1946 with the fairground playing boogie-woogie music, much to the consternation of some of the more sensitive residents of the town.

The Wheatsheaf was demolished in 1962 as part of a general improvement plan around the parish church and top of New Brook Street. Flower beds replaced the former advertising hoardings on the approach to the river and benches now stand on the corner of the former pub site. In 1964 another old pub, the Bay Horse, which stood on Leeds Road, was also demolished.

DID YOU KNOW?

There was a fight outside the Albion Hotel on the first Saturday of Feast Week in 1874. Revd C. R. Green from the adjacent parish church was on hand to separate the men by virtue of the fact that the good reverend was awaiting the arrival of a funeral. His intervention in the altercation resulted in him being 'bespattered with blood, which gave a somewhat extraordinary appearance to his clerical garb whilst performing the interment ceremony' a short time later. Only one of the men involved in the affray was apprehended and was subsequently sentenced at the Otley Police Court to six weeks imprisonment in Wakefield Gaol – it is not recorded if he also received a laundry bill from Revd Green.

During the 1870s many of the churches held concerts, lectures and entertainments. The Mechanics Hall opened in Grove Road and later the Working Men's Hall opened in Weston Road and a roller-skating rink was built in the town. (More on these in chapter three.)

Mr Septimus Wray opened his Pleasure Grounds on Bridge Lane in 1888, offering various entertainments. The grounds were extended to the north side of the river, with access via a suspension bridge where visitors could use a quarter-mile cycling track on what would become part of Ilkley Rugby Club's West Holmes Field ground. Mr Wray removed the bridge link in 1900. A parachute descent in August 1899, made from a balloon, attracted a large crowd. However, the local press reported that most spectators gathered outside the grounds to watch the stunt for free! The balloon ascended to around 1,500 metres/4,500 feet and drifted to the south-west before Captain Bidmead made his jump, landing near the top of Hebers Ghyll.

Despite the lack of support Mr Wray experienced for the stunt, generally the Pleasure Grounds were a very popular attraction for locals and visitors around the turn of the twentieth century, and included musical performances, 'moving picture' shows, waxworks and a menagerie. Mr Wray later established the Heysham Head Pleasure Grounds near Morecambe in 1926.

The 1880s also saw an increasing demand for a dedicated indoor public entertainment venue to be built. The Golden Jubilee of Queen Victoria in 1887 presented an opportunity for this.

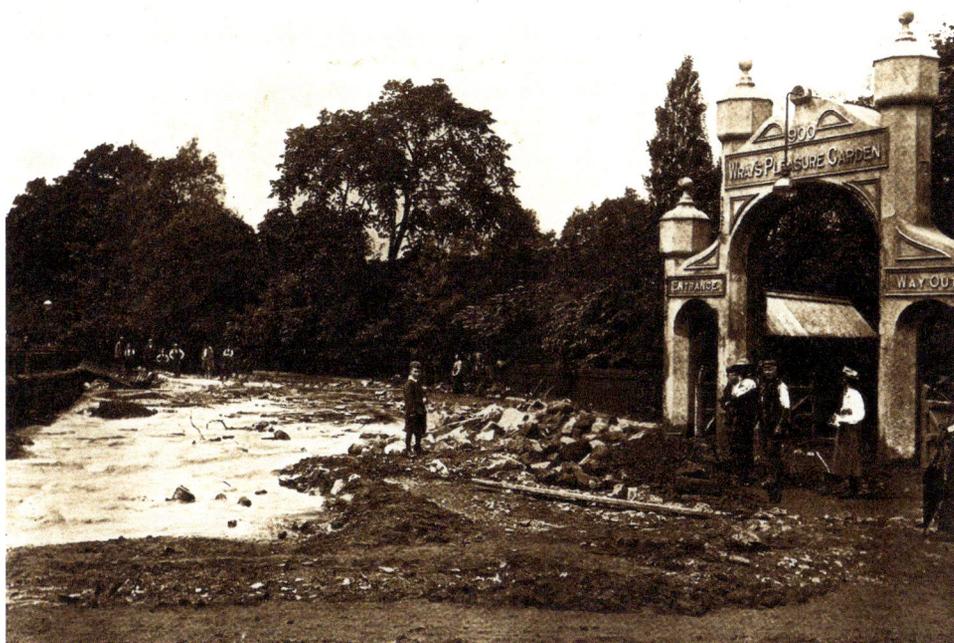

The entrance to Wray's Pleasure Garden, Bridge Lane, pictured here following the 'Great Flood' of 1900 (there will be more on the flood in chapter five). These gates stood where the entrance to the Riverside Hotel car park is today. (Sally Gunton)

The Victoria Hall

It was decided to build a hall and a swimming pool in the town to commemorate Queen Victoria's Golden Jubilee.

The Victoria Hall was opened at the junction of Leeds Road and Little Lane in March 1888. The *Ilkley Gazette* of the 24th reported: 'On Wednesday last the (Victoria Hall) was opened for the first time to the public, the boards being occupied on that occasion by the Ilkley Amateurs, who contributed one of their highly interesting dramatic performances.'

Shortly afterwards a swimming pool opened at street level. 'The Vic' remained popular until the turn of the century, eventually closing in 1901. The newspaper report of 8 June telling us:

> After some 14 years of existence as a public hall, during which period it has been chiefly used for theatrical purposes, this building has now passed into the hands of Mr George Ward, removal contractor, who is using the place as a storeroom for furniture.

The King's Hall

After the demise of the Victoria Hall there was an increasing demand for another theatre and entertainment venue to be built in Ilkley. The Ilkley Council decided to incorporate a theatre into its plans for a public library and town hall, thus placing the new venue more accessibly in the centre of town.

Shortly after the King's Hall opened in 1908 there were further calls to open another entertainment venue. Somewhere visitors could go in the event of inclement weather and listen to light music and perhaps even dance. Subsequently in 1914 the Winter Gardens was completed. This provided both a venue in its own right and an annex for the King's Hall next door, to which it was internally connected. At first critics thought the Winter Gardens would be something of a white elephant, but it proved much the opposite, and indeed continues in use today.

The King's Hall and Winter Gardens was used for many social events. In 1914 a recruitment rally was held in the King's Hall, encouraging many young local men to sign up for service as Kitchener recruits. Film screenings and theatrical productions were also popular, attracting big names of the day. In 1916, the music hall artist and comedienne Vesta Tilley brought her show to the town, which was hugely popular. During the 1920s the Ilkley Amateur Operatic Society was formed and performed its many and varied productions at the King's Hall. Dances in the Winter Gardens were also popular.

Other big names to have appeared at the King's Hall include Ken Dodd in the 1980s and Jimmy Osmond in 2018 – who'd have thought that in 1972!

DID YOU KNOW?
On 25 September 1981 the King's Hall played host to the Rock for Mandeville concert, in aid of the (now posthumously disgraced Jimmy Savile's) hospital charity. The gig included the Paul Winton Disco, local bands Chainsaw and 96 Tears and special surprise guests Status Quo, much to the amazement and vociferous approval of those of us in the crowd.

Cinema

In 1897 the first film shown in Ilkley was presented in the Victoria Hall. This was reported in the *Gazette* of 23 October:

On Thursday evening (21st) a series of animated pictures, recitals and sketches by Mr Walter Banks, was the fare provided, and a very excellent evening's diversion it proved to be. Amongst the pictures were representations of the Diamond Jubilee Procession, Naval Review, The Colonial Troops, The Queen at St Pauls &c.

On another occasion at the 'Vic', the audience wore 'analysers', familiar to today's cinema audiences as 3D specs – and this before the turn of the nineteenth century.

Following the success of the pictures at the Victoria Hall, performances were given elsewhere in the town. At one such screening in the Lecture Hall in Riddings Road, a train was seen in the distance drawing ever closer to the camera. At the critical moment the screen went black and a whistle was blown in the hall, apparently giving the 'finishing touch' to a wonderful presentation.

The film shows given in the Lecture Hall were organised by Mr Hibbert. He travelled widely during the summer months and gave illustrated talks with his films during the winter. His shows were always well subscribed. Mr Hibbert was later instrumental in establishing film shows in the King's Hall, not only travelogues but increasingly hiring comedies and general interest films as well.

In addition films were also shown in the Pavilion in the Riverside Pleasure Grounds and during the summer months of 1906 in the Rotunda, a large marquee erected behind Brook Street, where the car park is today. When the skating rink was demolished in 1912 the *Gazette* noted that it would have made an ideal cinema. Though plans were afoot to address this and Ilkley's first purpose-built Picture House opened in February 1913 on the back of the Grove by Croft Brothers. The first films shown were *A Canadian Travelogue, The Firefighter's Love, A Girl of the West* and four comedy films. The Grove was very popular and along with films shown in the King's Hall the population of Ilkley was well catered for and kept up to date with newsreels as well as the usual melodramas and comedies. In September 1916 the *Battle of the Somme* film was shown to great acclaim in the King's Hall, while at the Grove the films *At Bay* and *Gertie's Awful Fix* were being shown – though the Grove did also feature regular newsreels about the war too.

The local newspapers reviewed many of the films shown in the town, but frustratingly gave away the endings. For example, a film called *The Empty Cab* in 1919: '...The whole thing turns out to be a "spoof", engineered by the young man's father, though it encourages him to make good..."

The hero of the film is also provided with a wife as in true Hollywood style he falls in love with the girl rescued from the clutches of the villains – so now we don't have to bother going to see it as we know the plot twist!

In 1920 there were proposals for another cinema in the town to be in the Arcade between South Hawksworth Street and Church Street. This didn't happen, but in 1927 plans were approved to build a large cinema on Railway Road. The 'New Cinema' opened on 21 May 1928 with the film *7th Heaven*. The auditorium could accommodate over 1,000. While fronting onto Railway Road there was also a spacious ballroom. Soundproofing in the walls meant that patrons of the cinema were not disturbed if there was a dance in progress at the same time as the film show.

The two cinemas in Ilkley were incredibly popular during the classic years of Hollywood's film production. Throughout the 1930s and 1940s Laurel and Hardy and big musicals of the day entertained the Ilkley audiences. Generally the film programmes at both cinemas ran from Monday to Wednesday and a change from Thursday to Saturday.

By the 1960s cinema audiences were in decline. The Grove closed on 30 December 1967; the last film being *The Greatest Story Ever Told* and the building was demolished in early 1968. The Essoldo closed in 1969, the last film there being *The Italian Job* on 6 September. The building was also quickly demolished and was replaced with Hillards supermarket, opening in 1970. Following the demise of Ilkley's cinemas, Bradford Council used the King's Hall as a venue for its Civic Cinema. This ran frequently between 1978 and 1986, with shows usually on one or two nights every month between September and May.

With the opening of the fifty-six seat Ilkley Cinema in November 2015, the town once again has another venue for commercial film shows. A second screen opened there in August 2018, providing another forty-six seats in a smaller auditorium.

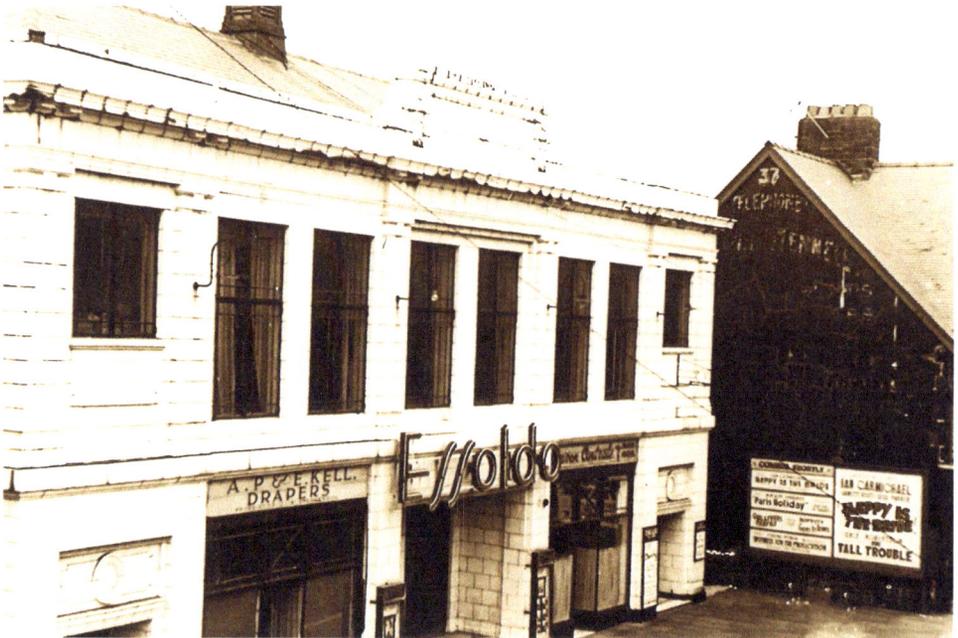

The advertising board on the right of this photograph was perfectly positioned for passers-by in Brook Street to look along Railway Road and see at a glance what was being shown at the cinema. This photo dates from 1958. The film *Happy Is the Bride* had a six-day run between Monday 4 and Saturday 9 August. The left side of the advertising board informs us of other films 'coming shortly', including *Paris Holiday*, which was to be shown the following week. (Mark Hunnebell)

DID YOU KNOW?
An incident was reported in the *Ilkley Gazette* in 1930 concerning a man standing in a queue that had 'reached altogether abnormal proportions'. It stretched from the New Cinema in Railway Road and around the corner into Brook Street. A friend spotted the man and asked what he was doing in such a queue. He replied that he was waiting to get into the station for a train back to Leeds, upon which his friend told him: 'Tha daft fool. Tha's been waiting here an hour and a quarter in't picture queue. When does tha think tha'll get back t' Leeds?' This begs the obvious question: what was the film so many were queuing to see anyway? The incident occurred on Easter Monday, so a check of the listings show it was *The Rainbow Man*, the first 'talkie' to be shown at the New Cinema, following the success of sound at the Grove Cinema shortly before.

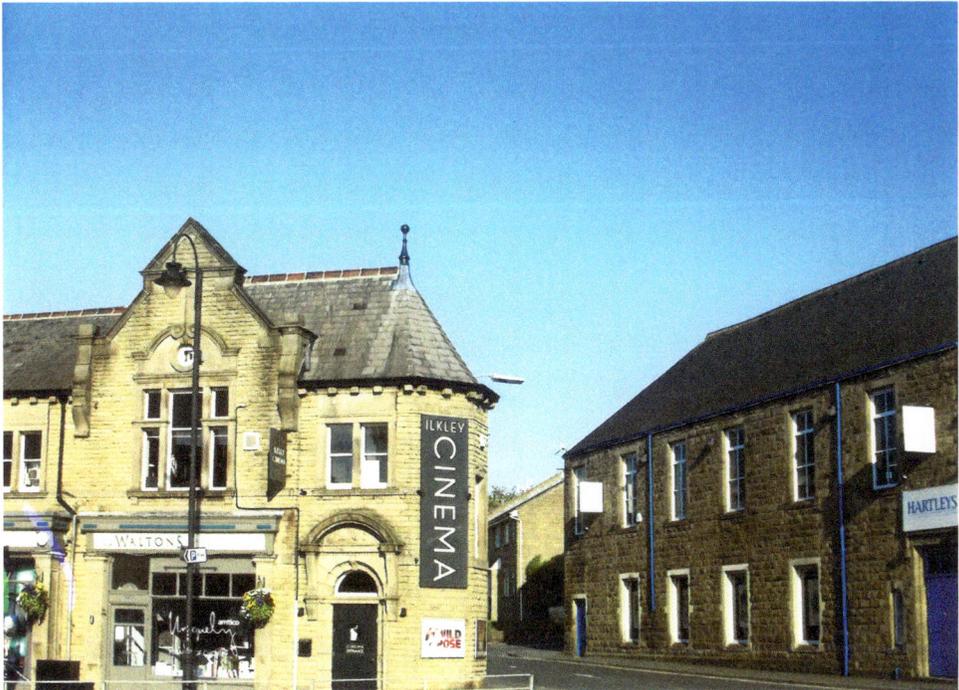

Forty-six years after the Essoldo closed, the Ilkley Cinema opened in November 2015, just across the road from the former Victoria Hall on Little Lane, which was the venue for the town's very first cinematograph presentation in 1897. (Mark Hunnebell)

Music and Drama

There are references of concerts held in the town going back into the nineteenth century. As already mentioned, the Wheatsheaf Hotel often staged musical evenings in the large room to the rear of the premises. Increasingly though entertainment was not restricted to the pubs. Concerts were also given in the Lecture Hall and in the Mechanics Institute.

With the opening of venues such as the Victoria Hall and later the King's Hall, musical performances drew wide audiences.

The Ilkley Amateur Operatic and Dramatic Society was formed in 1922 with a view to its first production, *Aladdin,* to be performed in the King's Hall the following year. The society had evolved out of the various amateur choirs, drama groups and 'Glee Unions' that had

been prevalent in the early years of the twentieth century. Annual productions were staged up until the Second World War. The society reformed in 1963 and staged *South Pacific* in the King's Hall in March 1964. The society went from strength to strength, buying its rehearsal rooms in the former Church Institute on Leeds Road and renaming the building Operatic House in 1970. The society now usually stages two shows each year in the King's Hall.

The town's other dramatic company, the Ilkley Players, staged their first production, *The Man From Toronto*, in St Margaret's Hall, Regent Road, in January 1929. The Players established a base in Sedbergh Chambers, Chantry Drive, in 1932. For much of the 1930s the company staged performances in the King's Hall, but in 1938 secured the rooms of the Liberal Club in Weston Road where they were able to create a small auditorium. Eventually the Players acquired the building from the Liberal Club in July 1960. It has since been considerably extended, with the addition of a studio theatre originally called The Pinfold in 1999. It was renamed The Wildman Theatre later that year after the late David Wildman, one of the long-standing members and leading visionaries in the development of the playhouse.

Another relatively recent addition to amateur theatre in the town is the Upstagers, established in 1987. Many of the teenagers and young adults in this highly polished company seek to pursue careers in the performing arts. The Upstagers perform a varied programme throughout the year at the King's Hall (and other theatres in the district), including an annual pantomime.

Dating from 1899, the All Saints Church Institute was built on Leeds Road. The building was later purchased in 1970 by the Ilkley Amateur Operatic Society as their permanent base, Operatic House. Some IAOS members will fondly remember post-rehearsal pints in the Wharfe Cottage Inn next door, as indeed will many locals attaining drinking age (or thereabouts) in the 1980s. Happy days! The former pub has now been converted into residential use. (Sally Gunton)

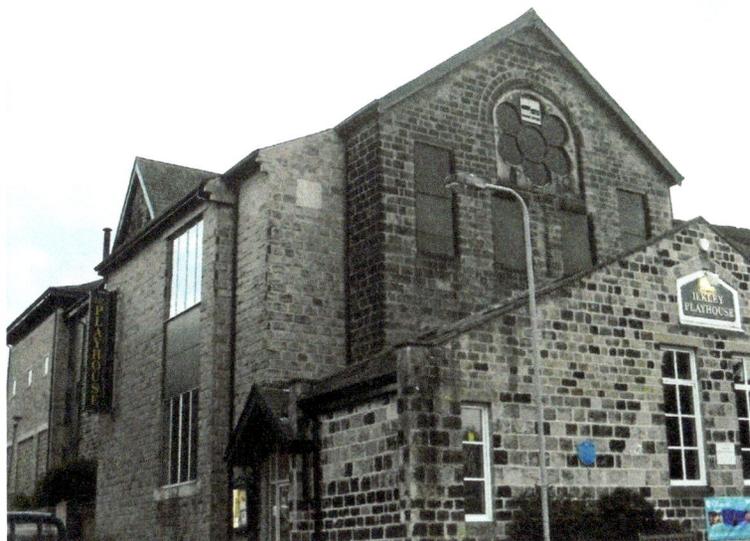

The Ilkley
Playhouse.
(Mark Hunnebell)

Hotels and Nightclubs

The Troutbeck Hotel opened in the 1860s and since 1985 has been a residential home. As hydrotherapy declined at the beginning of the twentieth century the Troutbeck struggled to survive and in 1908 it closed. During the First World War it was used as a billet for some members of a bantam regiment from Leeds in 1915, and after the war reopened once again as a hotel until 1985.

However, the Troutbeck's place in local folklore was secured when rock icon Jimi Hendrix played a gig there in the Gyro Nightclub on 12 March 1967. This was raided by the police after only two songs due to concerns about overcrowding. Perhaps the shortest and most obscure gig Hendrix ever played.

The Stoney Lea opened in Cowpasture Road in the 1880s. The hotel survived until 1981 when it was demolished to make way for housing. During the 1960s, the Stoney Lea was also a popular music venue. While the Troutbeck is remembered for its infamous 1967 Jimi Hendrix gig, other fledgling acts also appeared at these venues including Rod Stewart and a lesser-known band called The Rocking Vicars – controversial because they weren't vicars at all. While they might have been an obscure 1960s band, their guitarist went on to find international fame as Lemmy in the band Motorhead.

Bands played and dances were held at many venues around the town on a regular basis over the course of the twentieth century, and nightclubs became popular too. Among these in the 1970s was Samantha's nightclub at the Cow and Calf Hotel and the Minstrels Gallery restaurant and nightclub on Leeds Road. This became another classic venue: the Il Trovatore nightclub, known to anyone growing up in Ilkley between the late 1970s and the mid-2000s simply as 'The Trav'. In the 1980s Madame's nightclub entertained its patrons in the Listers Arms Hotel.

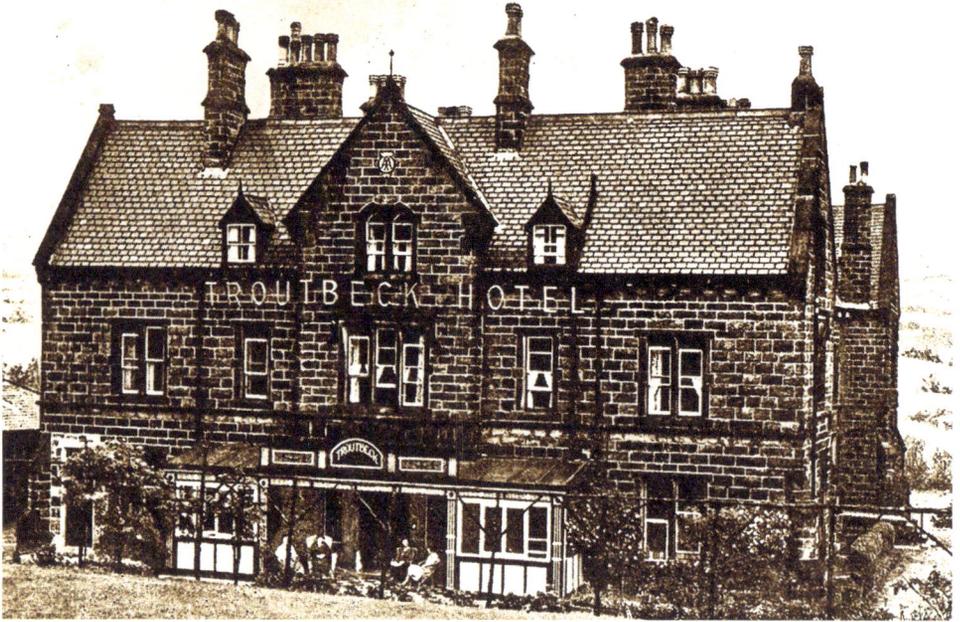

The Troutbeck opened as a hydro in 1863. It will be forever remembered for its Jimi Hendrix gig in 1967. (Sally Gunton)

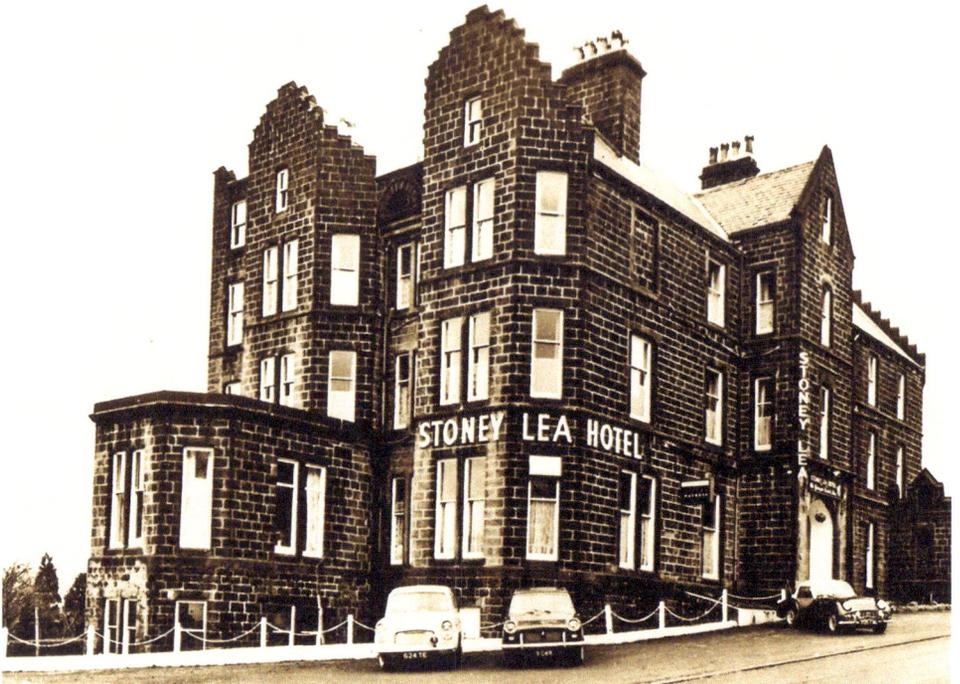

The Stoney Lea Hotel in the 1960s. There are three classic cars parked outside: a Ford Popular, a Triumph Herald and a Triumph TR3. (Sally Gunton)

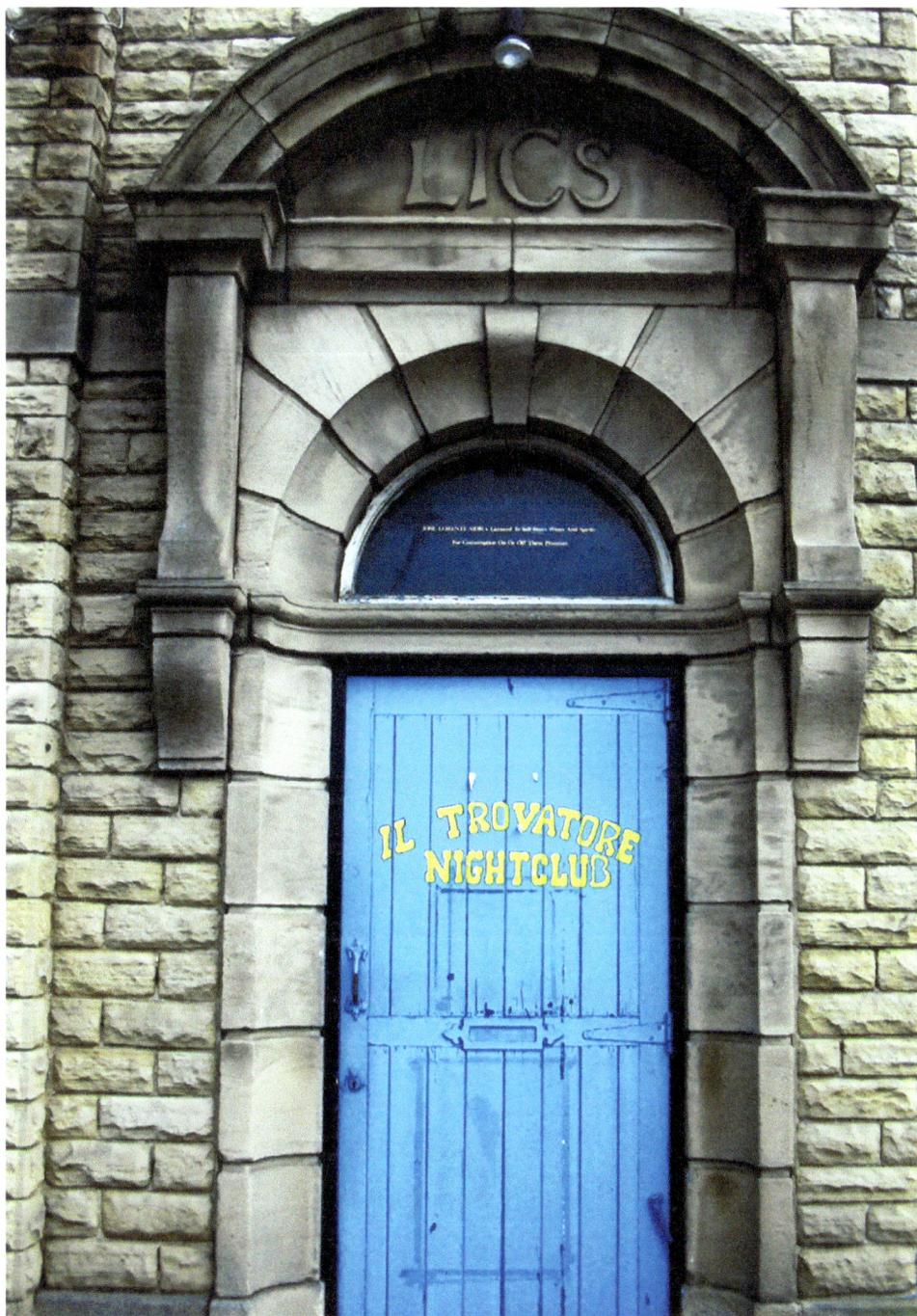

The Il Trovatore nightclub, Leeds Road. What went on up the stairs behind the blue door is known only to those that were there! 'The Trav', as it was colloquially known, closed its door for the last time in February 2006 and became part of Ilkley folklore. Originally the building was completed in 1899 and, as the lettering above the door alludes, was owned by the Leeds Industrial Co-operative Society until the early 1960s. This doorway is now the entrance to the Ilkley Cinema. (Mark Hunnebell)

3. Sports and Clubs

A wide range of sports, political and social clubs have been represented in the town. Some still survive and are thriving, while others have come and gone. Following the land sales of the 1860s and the development of housing and increasing population, attention also turned to providing for the social needs of the town's residents. Entertainments held in public houses and church socials continued, while other purpose-built venues were being considered as public halls and private clubs. In March 1870 plans were in hand to establish a Mechanics Institute and meetings by representatives of the newly formed Ilkley Local Board worked towards this through a committee set up for the purpose: 'The plans of a public hall and institute, proposed to be erected by Mr Tunstall of Leeds, in the Grove Road, at the junction of Gill Road, were submitted to the gentlemen present. The general feeling of the committee was entirely in favour of the scheme...'

However the plans quickly ran into trouble and the arrangements with Mr Tunstall stalled. The next edition of the *Gazette* reported: 'The committee then proceeded to the discussion of the offer of a room from Mr J. Smith. The room is situated at the back of that gentleman's new residence in the Grove Road...'

Mr Smith's offer was accepted, and the Mechanics Institute opened at the end of April 1870. It survived for just two years, closing in April 1872. In the years following there were demands for provision of another facility for the benefit of working men. To this end, in 1875 proposals were advanced to open a Working Men's Hall in Weston Road. This was approved, construction began and in 1876 the hall opened. A few years later, this venue became the Liberal Club. The building eventually became the Ilkley Playhouse, which remains popular today.

Spectator sports included the Ilkley Horse Races, held on the open fields to the north of the river, the land that now forms the East Holmes Fields, rugby club, cricket clubs and the Lido. Physical pursuits gained in popularity too with a desire to participate as well as spectate, including roller skating. In the 1870s Mr Underwood of Bradford decided to bring this pastime to the public of Ilkley. A site was found on the 'Old Cricket Pitch' adjacent to the rear of the Listers Arms Hotel. The *Ilkley Gazette* of 23 March 1876 informs us: 'It is intended to erect a temporary skating rink in the old cricket field. The work has been commenced and should the rink prove a success it will be made permanent.'

Evidently the popularity of roller skating was such that this became the case and the rink was regularly advertised in the local press.

The land where the rink had stood was redeveloped in the 1880s when the railway was extended to Skipton.

Roller skating enjoyed a revival in the early years of the twentieth century when another rink was built on South Hawksworth Street opposite the arcade and not far from where Mr Underwood's rink had been, around the corner in Cunliffe Road. Construction

of the new building began at the end of June 1909 and a report appeared in the *Ilkley Gazette* of 3 July:

> On Monday a start was made with the erection of the Ilkley Skating Rink. The site is at the junction of South Hawksworth Street and Cunliffe Road, opposite the Constitutional Club, and has been leased from Mr Henry Ellis, Linnburn, Ilkley. The building will be of considerable dimensions, having a skating area 100 feet by 90 feet. The front elevation will be of wood, nicely designed, moulded and decorated, and the rest of the building in painted corrugated iron ... The opening has been fixed for Saturday July 24th...

The rapid erection of the rink proceeded during the course of the next few weeks, though in the event, it was not ready for opening on 24 July. Instead the *Gazette* of that date printed an advertisement stating that the rink would open the following Friday, 30 July.

The rink was a very popular diversion and various events were held there to tap into the popularity of the 'craze', such as exhibitions of fancy and trick skating. And on 30th September a novelty cricket match on skates took place between local tradesmen and the rink staff. The rink staff, perhaps unsurprisingly, won the contest by 25 runs to 18. Though to score 18 whilst on roller skates, the tradesmen clearly weren't disgraced and made a good account of themselves!

Late in 1909 the rink was sold and new owners took the venture on. There was 'No rinking on Christmas Day' but on 27 December a fancy dress carnival was held.

Within a relatively short space of time the popularity of roller skating diminished and the rink closed. The building was sold and was demolished in 1912. The *Ilkley Gazette* of 7 September reported:

> This week a commencement has been made with the demolition of the skating rink in South Hawksworth Street, the structure having been purchased by Mr Robert Gillam, iron and steel merchant, Hammerton Street, Bradford, who intends to dispose of the place piecemeal.

In October 1912 the paper reported on the demise of an adjacent building, also being described as being 'opposite the Constitutional Club', the late Tom Richardson's cobblers shop. It was noted that the demolition of the workshop would be of interest to the older generation of Ilkleyites, who remembered him breeding canaries and telling stories, 'some of them very tall stories too, for he had behind him a considerable seafaring experience and a true sailors capacity for spinning yarns, with a kindness of heart that more than anything delighted in pleasing little children.'

The land where the skating rink (and 'Cobbler Tom's') had stood was eventually built on again with the construction of the West Yorkshire Road Car Co. Ltd bus garage in 1928. This survived until the reorganisation of public transport in the late 1980s and was demolished to make way for the Moors Centre adjacent to the town's central car park.

Roller skating enjoyed a short-lived revival before the Second World War, with the Ilkley Skating Club holding meetings in a large room in the Listers Arms Hotel. In the 1970s the variation of skateboarding became popular among the younger population.

THE ILKLEY GAZETTE, SATURDAY, JULY 3, 1909.

The advert implied a palatial skating rink, with a grand façade... (*Ilkley Gazette*)

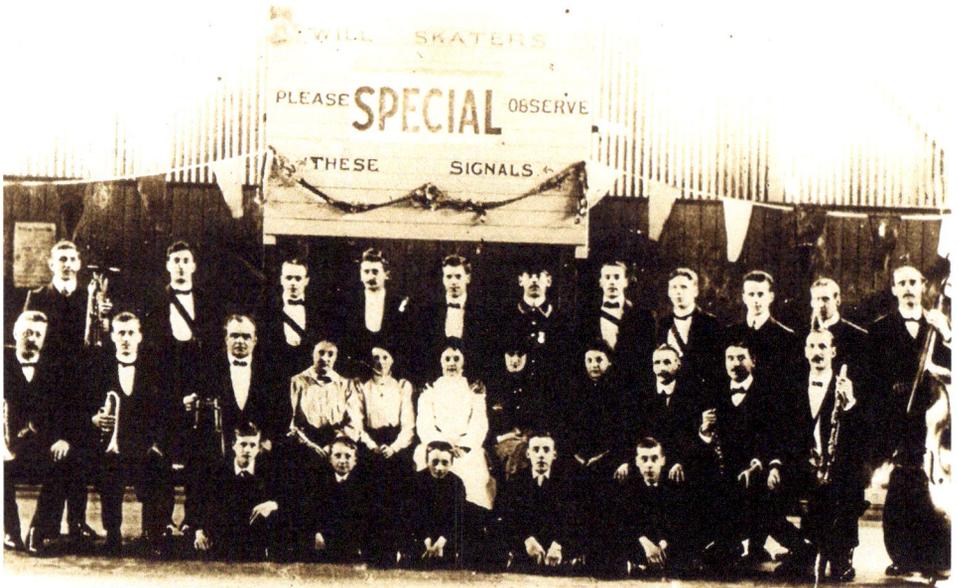

...While the reality was somewhat more mundane: corrugated iron and wood, as can be ascertained from the background to the rink staff and band. The building was erected and ready to cash in on the skating craze in just four weeks. (Caroline Brown/Ilkley Library)

There were hopes that purpose-built skate park facilities would be built to accommodate this. In the summer of 1978 Bradford Council thought laterally and bought a job lot of conveyor belt material from coal mines in South Yorkshire and some of it was brought to Ilkley and laid in West View Park (now Darwin Gardens Millennium Green) at the top of Wells Road. This generated considerable criticism in the local press. Not because of unruly youths swarming the facility, quite the opposite. It was felt that the simple strip of rubber belt was an insult to the town's youth and woefully inadequate to hone their skating skills. The 'track' didn't remain in place for long. It was considered a joke by the town's youth and wasn't used.

The 'Generation X' kids of the 1970s grew up and found other interests, though for those growing up after them skateboarding continued to be popular, proving the older generations to be wrong in that it wasn't merely another 'passing fad'. Eventually a dedicated charity, Pipe Dream, was established to raise funds for a purpose-built skate park to be installed in the town. This was completed adjacent to the New Bridge in 2003, twenty-five years after the debacle of the conveyor belt 'skate track' in Wells Road.

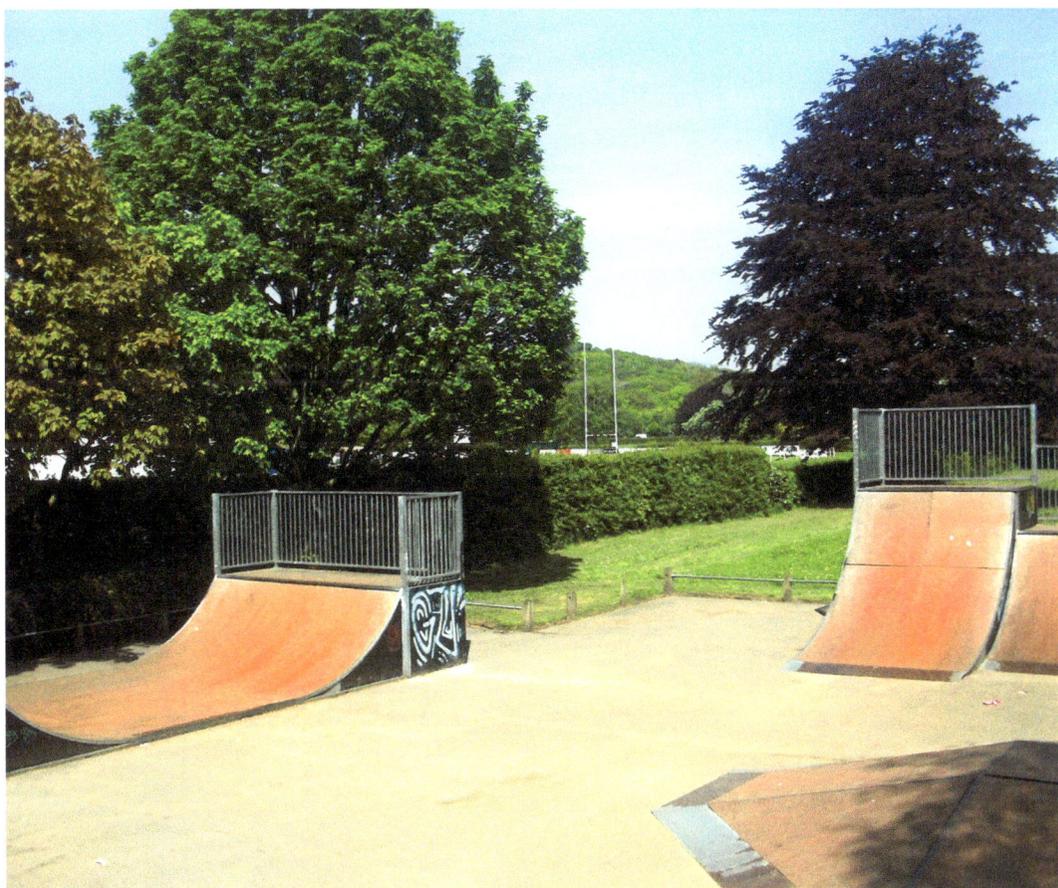

Ilkley Skate Park. (Mark Hunnebell)

Black Hats Versus White Hats Cricket

The Black Hats versus White Hats cricket matches started as a 'Tradesmen's Match' in 1880, which was organised by William Lister and John Beanlands to assist the fundraising efforts of the Ilkley Cricket Club.

The first match was arranged for 'Feast Week' on the 23 September. Mr Beanlands and Mr Lister each captained the two teams of twenty players. However, in this opening 'Tradesmen's Match' the teams did not play as Black Hats or White Hats. Mr Beanlands team scored 142 runs, beating Mr Lister's team's 128. The event was deemed a success and was repeated again the following year, this time with Mr Lister's team being victorious. In 1882 the teams wore the black and white hats for the first time, though in 1883 it was red versus white rosettes. The weather for the 1883 match was appalling but the teams decided to play nevertheless. It was said: 'Whether the weather was cold or hot, they'd weather the weather, whether or not!'

In 1884 the teams returned to the Black and White Hats, creating the tradition, with the exceptions of 1887 when it was played as a 'War of the Roses' match and 1990 when it was played as 'Romans versus Britons" – the latter to tie in with the theme of the Ilkley Carnival. From 1888 up to 1913 the matches continued, with the exception of 1902 when the tradesmen decided to go on a day trip to Blackpool instead.

After the First World War the matches were revived in 1920 and played until 1938. In 1926 a novel introduction to the series was reported in the *Ilkley Gazette:*

> The match was marked by two innovations, a series of children's sports and the appearance of a lady player. The first was pre-arranged, the second was quite unexpected, but both were decidedly enjoyable...Miss Sally Hanson, the first lady player to take part in these matches, turned out on behalf of the Midland Hotel. (Part of the Black Hats team)

In 1930 there was a fiftieth anniversary match and the following year saw a unique diversion in the series. It was the first and only time that a team from Otley was invited to play, so there was a real danger that the trophy could leave Ilkley.

Ilkley batted first and scored 74. Otley came to the crease and appeared on target to win, but suffered a dramatic batting collapse, finishing on 67. What if Otley had won? It would have been disappointing for Ilkley to have lost on the day but in the bigger picture could it have been the start of a sporting rivalry that would have endured between the two towns?

In 1932 the match very nearly didn't happen at all. There was no suggestion of inviting Otley back for a rematch and the organisers were struggling to assemble the teams. Then at the eleventh hour a team of ladies were mustered to represent the White Hats and the match went ahead after all.

The ladies versus gentlemen theme continued for the 1933, 1934 and 1935 matches. On each occasion the ladies White Hats team were victorious, although a somewhat bias handicapping system was in force during these matches, ensuring the men, some of whom were regular cricket players, didn't get too far ahead of themselves. In 1936 it was decided to make things more evenly balanced with the introduction of mixed

teams – though a handicapping system was still applied to the male players. The White Hats won 62 runs to 61 under the captaincy of Miss L. Bradshaw.

The series was interrupted again by war and was not contested between 1939 and 1944. In 1945 there was a one-off match during 'Thanksgiving Week' and then the series ended for thirty-three years until another one-off match in September 1978. In 1980 it was revived again as a bi-annular event as part of the Ilkley Carnival, held on the May Day bank holiday up until 1990, when the Britons beat the Romans 8 runs to 6 – the lowest ever score, with both teams having just fifteen minutes each at the crease.

In 2016 there was another revival with the Black Hats being victorious.

DID YOU KNOW?
In December 1906 the tradesmen organised a Black Hats versus White Hats rugby match. It was hoped to have teams consisting of twenty-seven a side but in the event twenty-three turned out for the Black Hats and thirteen for the White Hats. Despite what may seem to have been a forgone conclusion, four fifteen minute ends were played and the score was nine all at full time!

Black Hats and White Hats, 1931. Ilkley in white hats took on the black hats of Otley. (*Ilkley Gazette*)

Swimming Baths

The river was always a popular diversion for swimming during the summer months. There was a bathing pavilion lower downstream to the Crum Wheel bend, but in the 1880s there were hopes of better facilities. The proposed Victoria Hall would also include a swimming bath. The *Ilkley Gazette* reported on the progress being made with the construction. This from the paper of 23 July 1887:

> The New Swimming Bath.
>
> Messrs. Dean Brothers' new swimming bath which is in the course of erection near the Steam Laundry, Leeds Road, is, we understand, to be opened for trial today (Saturday), when a small charge will be made for admittance. The bath which is 8 yards wide by 20 yards long will be fed from a spring close by supplying 30 gallons per minute, the water being forced from a tank constructed for storage by means of steam, thereby supplying a constant stream of pure aired water. The bath is beautifully constructed, having a railing running along either side and at the six foot end, to which are attached spittoons, in order to avoid pollution as much as possible, while at the shallow or three foot end, are steps at either side for ascending or descending the bath. The floor and sides are tiled, while boxes for dressing are to be erected on the south side.

The following week the paper reported that large numbers had availed themselves of the opportunity of using the new pool, and looked forward to the completion of the building.

Despite the fact that the Victoria Hall theatre closed in 1901, the swimming bath opened during the summer season that year. When it was announced that Mr Binns would no longer be in charge of the baths, the Swimming Club hoped to take over the management of the facilities but this didn't happen until 1902. The club made various improvements, including a ladies dressing room and separate bathing for ladies on Wednesday afternoons. Children were also welcome after school on Friday afternoons, with the 1*d* admittance reinstated.

Although it was appreciated that the bath had been reopened, it was apparent that the facilities were less than ideal. There were repeated calls for a better public swimming pool to be provided, perhaps in the proposed Town Hall. When the Town Hall was built in 1907/08 it included a library and public hall but, alas, no swimming pool, though in 1906 the council did arrange for pipework to be carried out for the Victoria Baths and the pool received a supply of waste hot water piped from the Ilkley Brewery – perhaps a source of mirth among clients of the various hostelries in town pertaining to either watered down beer or hopeful visits to the baths!

By the time of the First World War the Swimming Club was still in charge but was finding it financially difficult to maintain. After the war the bath was taken over by Prof. Modley, the father of the future radio star and actor Albert. Prof. Modley advertised mixed bathing, whereby ladies and gentlemen could use the bath at the same time, a sign of the more liberal attitudes that were beginning to emerge after the war.

In 1924 the Ilkley Brewery that had supplied hot water to the bath for eighteen years closed. This presented a problem for Prof. Modley, though a supply of hot water was

obtained from the laundry next door. This only lasted a short time and the Victoria Baths closed in 1925. Prof. Modley covered over the swimming pool and installed a gym instead. This proved popular for a few years, promoting an amateur boxing club in the town. Prof. Modley died in 1928 and the Boys Brigade took over the running of the gym, but in the early 1930s the whole building became a furniture saleroom. The issue of a public swimming pool rumbled on in the Council Chamber and the local newspaper for almost a decade until the opening of the Ilkley Lido in 1935.

In 1933 the Ilkley Urban District Council was finally in a position to be able to secure loans and agree to the proposals. It was decided to build an outdoor bathing pool. This was going to be constructed on the East Holmes Field, adjacent to the river, but the site was surveyed and found to be unsuitable due to underlying shale, so a second site not far from the one originally proposed was found to the north of Denton Road. The site was prepared and construction began in earnest during the summer of 1934, and the pool was ready for a grand opening in May 1935, coinciding with the Silver Jubilee celebrations for George V. The new pool provided an ideal venue for the town's celebrations.

The summer of 1935 was glorious. Crowds of people, locals and visitors made full use of the new pool and a handsome profit was returned to the council. This helped pay off some of the loan and provide additional changing facilities, which were completed to the east side of the pool in time for the start of the 1936 season.

Despite the outbreak of war in 1939, the Ilkley Lido opened throughout the years of hostilities, opening in May and closing in September.

The Lido maintained its popularity over the following decades. In 1964 there were plans to hold an event there for teenagers called Beat and Bathe. Concerns over possible trouble saw the Ilkley Council prevent it.

In 1967 a less controversial event was allowed to take place. The BBC had just launched its new entertainment programme *It's A Knockout*, pitting rival towns against each other with a mix of silly games, many involving getting wet. Ilkley took on Otley, but were roundly beaten 15-2. A large crowd from all over the area descended on the Lido to see the fun, and perhaps get on the telly.

Although the Lido continued to be popular there were increasing demands for an indoor pool that could be used year round – reminiscent of the demands at the beginning of the century. In 1972 work finally started on a new indoor pool adjacent to the Lido. It was completed the following year, opening on 14 June 1973 with an 'official' opening a little later on 21st September. Forty-eight years after the Victoria Hall bath closed, another indoor pool opened in Ilkley.

In March 1998 a proposal to construct a plastic dome over the outdoor pool was debated by the Ilkley Parish Council. It was decided that it would be a visual intrusion, amid reports in the paper headed, in typical style, 'Dome a washout with Councillors' and using phrases such as 'plan has had cold water poured over it'. The scheme was derided and came to nothing. In 2012 further plans were suggested for replacing the indoor pool with a new structure built in an art deco design, echoing the 1930s style of the Lido. This plan, again, has yet to come to fruition.

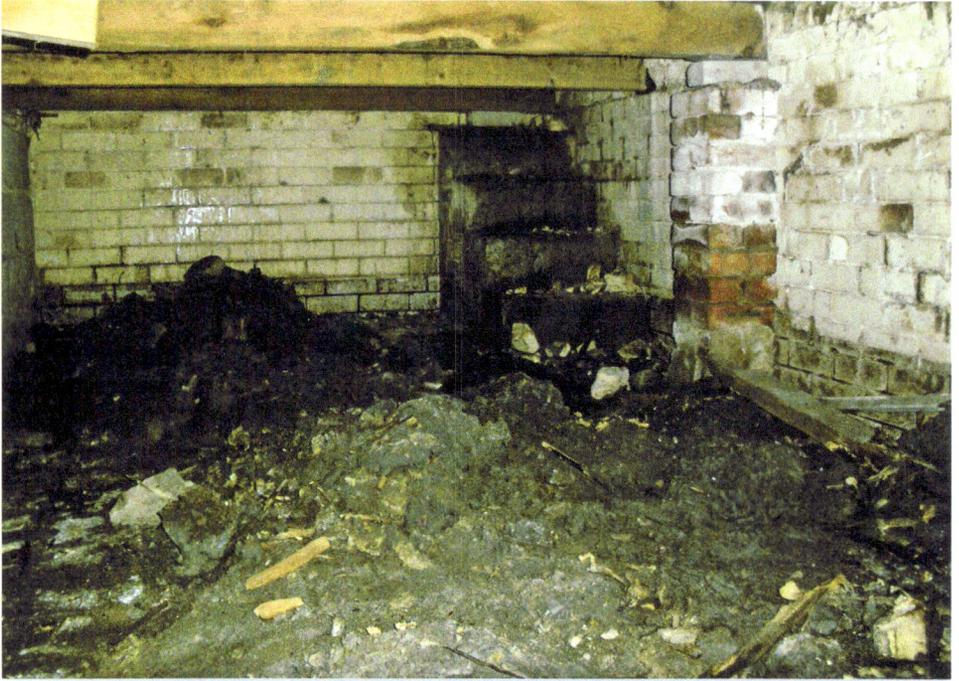

The Victoria Hall Pool under the floor of Hartley's Salerooms on Little Lane. In the top part of the image the pool's glazed bricks can be seen looking towards the steps at the shallow end. Red-brick supports have been installed along the length of the pool to hold up the wooden floor above. The lower part shows the tiles on the bottom, visible in places through the detritus of many years. (Mark Hunnebell)

The old Brewery building. This became part of Dalton's Moorland Food Factory manufacturing cereals, and then in the early 1950s Spooner Engineering. However, a careful look around the top of the tower gave away its former use – lettering announcing 'Ilkley Brewery' could be made out until demolition in 2011. (Mark Hunnebell)

In 1933 the plan for the proposed outdoor pool on the East Holmes Field was published in the *Ilkley Gazette*. (*Ilkley Gazette*)

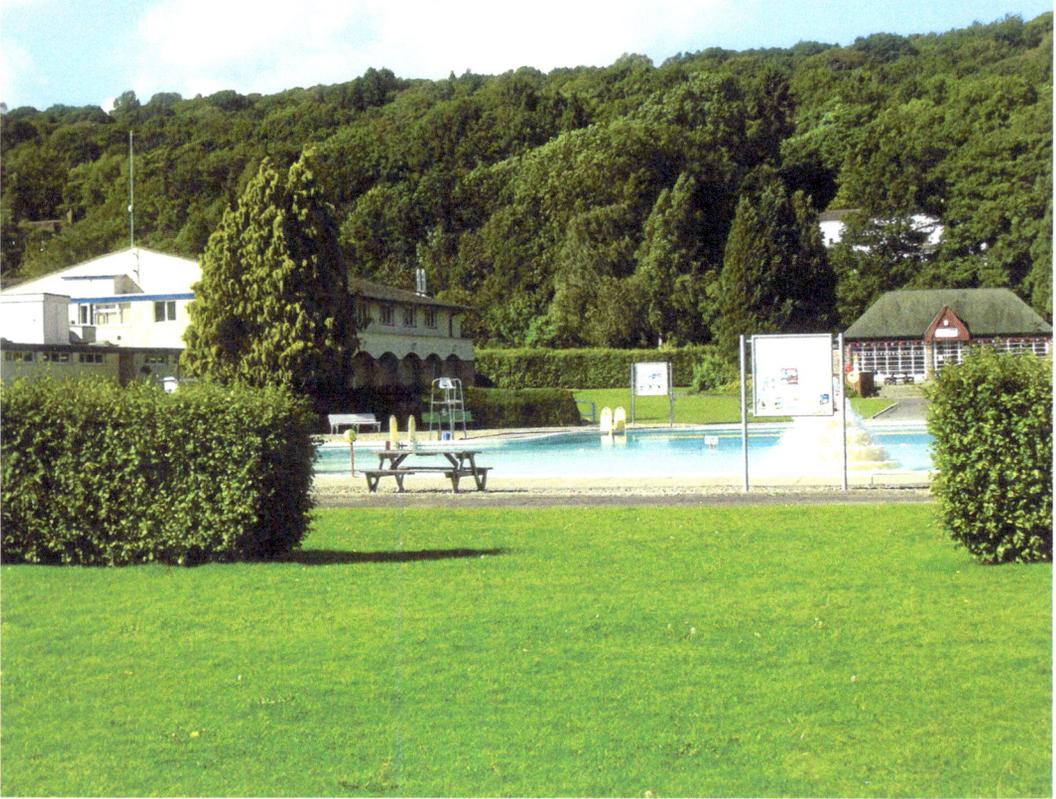

The indoor pool was built in the north-western corner of the Lido grounds in the 1970s, while the Lido itself, dating from the 1930s, continues to be popular during the summer months. (Mark Hunnebell)

Golf

Golf gained in popularity during the 1880s. In 1885 a nine-hole course opened for patrons of Ben Rhydding Hydro. When the hydro was demolished in the 1950s the golf course became a private members club that still exists today.

In the early 1890s a golf course was laid out on the moor (there will more about this in chapter four), and in 1898 the Ilkley Golf Club moved from here to a new course to the north of the river, where it remains today. The moorland course continued in use by members of the original club.

What about other sports clubs in the town? Here's just a small selection, as an entire volume could be written on the history of each.

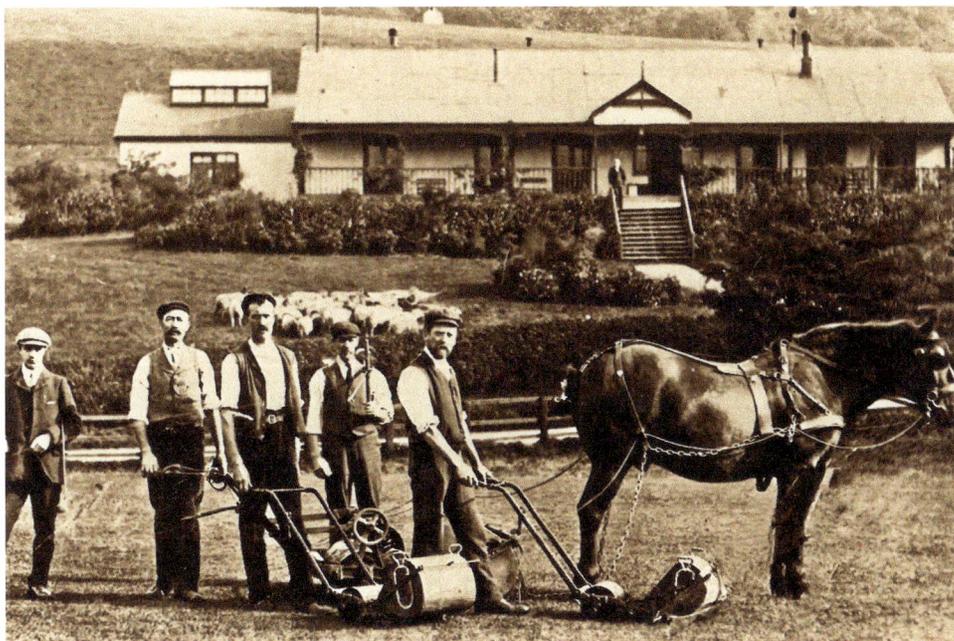

Ilkley Golf Club, 1900s. Here some of the ground staff are pictured outside the old pavilion. Third from the left in charge of the lawnmower is the green foreman Mr Edward Hunnebell, my great-grandfather. He came to live in the Ilkley area around 1880, when he was employed as a farm labourer at Burley-in-Wharfedale. He later moved into Wellington Road and obtained a job with the Ilkley Golf Club. He died aged only fifty-three in July 1914. (Mark Hunnebell)

Cricket

The Ilkley Cricket Club was formed in the 1850s and has played at several locations around the town: firstly on a field behind the Lister's Arms Hotel, then on a field west of the Old Bridge. The club then moved to Railway Road, behind the Crescent Hotel, and many matches were played there, including the Black Hats versus White Hats matches of the 1880s and much of the 1890s. In 1898 the club moved to a site north of the river on Denton Road, where it remains today.

Olicana Cricket Club

A rival to the Ilkley Cricket Club, the Olicana Club takes its name from the Roman appellation for the town to provide a distinction between the two clubs. The Olicana ground is to the east of the Lido.

Tennis

The Ilkley Tennis Club was formed at a very well-attended meeting held in the National School on Leeds Road on 9 April 1880. The club's ground was subsequently established west of the Old Bridge, on land that had recently been vacated by the Ilkley Cricket Club. An annual tennis tournament was established, which is still contested, and over the years various improvements and extensions to the club have been made.

Football

The term football is not to be confused with the game of rugby! Many reports in the local press make no distinction and reports of 'football' matches are in fact reports of how the local rugby team fared. (Hence the term 'soccer' arising as a corruption of 'Association Football' to differentiate the two games). In Ilkley, soccer matches were frequently played on a field adjacent to Victoria Avenue. In 1956 the British Legion football team became the Ilkley AFC team.

Other Sports

There are of course many other sports and games too numerous to detail here, and beyond the scope of this book. However, Ben Rhydding is home to a very successful sports club, established in 1922, with hockey being a main feature. Bowling is another popular pursuit, and the Ilkley Bowling Club has a very strong membership, both as a social venue and a sports venue. Indoor sports include squash, played at the tennis club, and badminton, played in church and school halls. Ilkley also has strong representation in the local snooker leagues, and is an established feature within other clubs too. For example, the bowling club also has a snooker team. Similarly the games of darts and dominoes have enjoyed their successes over the years with many of the local pubs represented at some point.

Other Clubs

Ilkley Cycle Club, Motor Club, Angling Association, Wharfedale Naturalists, and various 'Friends' groups continue.

Other social clubs have been well represented in the town. The Liberal Club used the former working men's hall on Weston Road, eventually making way for the long-term tenants, the Ilkley Players, to take on the premises as their own.

The Constitutional Club enjoyed considerable popularity and moved to its present location in South Hawkesworth Street from Tower Buildings in 1898.

The Olicana Bridge Club meets in the upper rooms of what used to be the post office in Wells Road.

Ben Rhydding Men's Club opened in 1913, and still survives through having been more latterly renamed Ben Rhydding Snooker and Billiards Club.

The Ex-Servicemen's Club, based in the Arcade, moved to Tower Buildings. In 1921 this became the British Legion Club, which moved premises again in 1928 to Mornington House, before moving again in 1949 to Annandale on Wells Road. In the 1990s this became the Wells Club, a short-lived private members club, before the premises were converted into apartments. The remaining British Legion members then met in the Riverside Hotel until 2012 when they amalgamated with Addingham.

The Hollygarth Club, established after the Second World War, moved from its original premises on the north side of Leeds Road near Colbert Avenue into its current premises formerly occupied by the Co-Operative Society in 1965. The building has been much extended and modified during the years since.

A popular pastime in the 1930s among the more affluent, gliding clubs sprang up in many suitable places around the UK. Spurred on by the popularity of all things aeronautical in the wake of pioneers such as Alcock and Brown, Charles Lindberg, Amy Johnson and Howard Hughes, gliding was a cheaper – and it was noted quieter – option than that of powered aircraft.

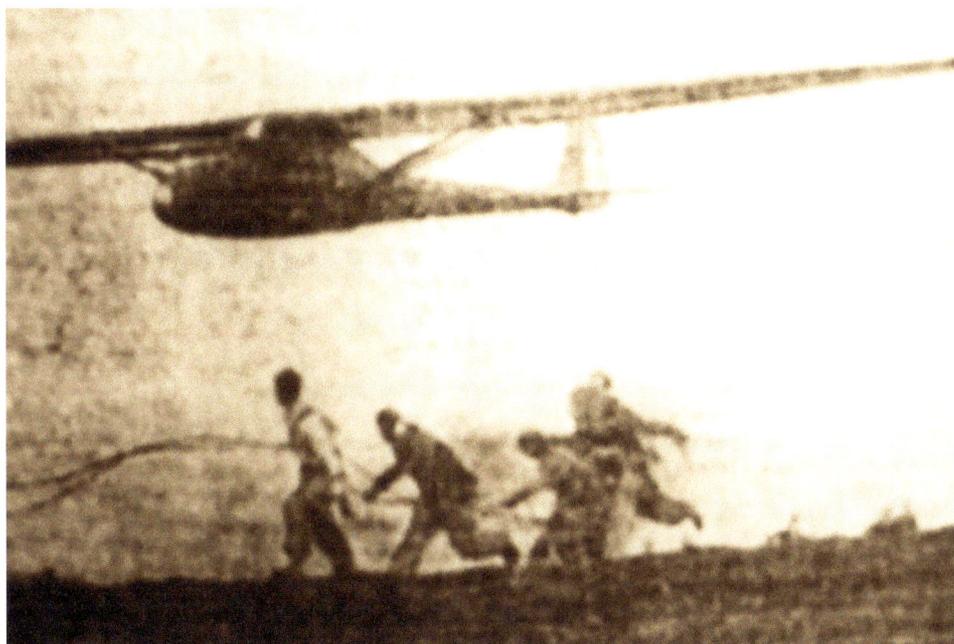

Glider at Beamsley Beacon. (*Ilkley Gazette*)

The Ilkley Gliding Club was established in 1930 and members invited the prominent Austrian pilots Herr Kronfeld and Herr Maggersuppe to come to Ilkley and give a demonstration at Beamsley Beacon. A truck was used to transport the catapult launching equipment to the summit of the beacon, no mean feat given the terrain and vehicles available, and successful launches were made, with a great number of spectators making the journey up the hillside from Ilkley and Addingham.

Local interest in gliding was not renewed after the Second World War, though in the 1970s and early 1980s hang-gliding enjoyed a degree of popularity and the ridge to the east of the Cow and Calf Rocks was used by participants in the sport. Subsequent changes to the local byelaws now prohibit this activity.

DID YOU KNOW?
The first aircraft to overfly Ilkley was on 11 June 1914. The pilot was Mr Harold Blackburn of Leeds making a flight from the Lancashire coast to Harrogate. The *Ilkley Gazette* reported that those at a church bazaar being held in the Wesleyan Assembly Rooms came rushing outside at the shouts of 'there's an aeroplane passing over', while others in various entertainment places were disappointed to have missed the spectacle. One man who witnessed the event proudly said: 'To be able to say that you saw the first aeroplane that ever passed over Ilkley is a very different thing to seeing one later.'

4. The Moors

White Wells

The whitewashed landmark standing out on the moor has a long and interesting history. A popular local story tells of a shepherd who hurt one of his legs while out on the moor. He found a very cold spring and bathed his wounds. These healed remarkably quickly, and this was attributed to the 'healing properties' of the water. No one knows who the shepherd was, or indeed if the story is true, but there has been medicinal bathing at the White Wells spring since around 1700. At that time the bath was to the rear and slightly higher up the hill than where the building that is familiar today stands. In 1791 Robert Dale, under the auspices of Squire William Middelton, built two new baths at White Wells.

The baths proved very popular and established Ilkley as a spa town, as mentioned in chapter one. In 1830 the Ilkley Bath Charity was formed, and the Charity Bath was built to the west of White Wells. It has since been converted into a public toilet – firstly in 1910 and more recently replaced in 2005.

As the nineteenth century drew to its close the popularity of 'taking the waters' at White Wells waned. Although bathing was possible as late as the 1920s, the growing number of casual visitors sought refreshments. Owing to the decline of the number of bathers there had been suggestions that the property should be demolished in favour of a terrace and purpose-built refreshment rooms. This was adapted and instead of demolition a café was built nearby. For fifty years between 1921 and 1971 the Moorland Tea Pavilion to the east of White Wells was popular with visitors. During the 1920s ham and eggs was something of a signature dish at the pavilion. Between 1930 and 1964 Mrs Williamson ran the café, establishing herself as a familiar figure to generations of locals and visitors. She retired in 1964 and Mrs Gregson took over the tenancy. By the early 1970s uncertainty over the future of her tenancy with Ilkley Council and persistent vandalism of the pavilion led to it becoming beyond economic repair. The building was demolished on 21 October 1971 in a controlled burning organised by the council and overseen by the local fire brigade.

In my book *That Place on Ilkley Moor: The History of White Wells* it seems that I killed off the pavilion's previous tenant Mrs Williamson somewhat prematurely! Since publication in 2010, further information has come to light that she retired in 1964 and enjoyed around another twenty years of life. I can only apologise for this error, while fulfilling my promise to update and amend any inaccuracies that are brought to my attention.

As well as Mr Butterfield being in charge, David Scott from Halifax also became involved at White Wells. In 1901 he was giving flamboyant 'orations' to visitors, extolling the virtues of the 'Roman baths' – an erroneous description that persists to the present day.

The baths at White Wells were built in 1791 during the reign of George III, so contrary to popular belief and the pronouncements of Mr Scott, the baths are neither Roman nor Victorian.

The *Ilkley Gazette* printed an article on the orations of Mr Scott, with a jocular tone:

If any of my readers have not yet paid a visit to the Old White Wells and listened to the bathman's paralysing oration in praise of the 'mellifluent, diaphanous, limpid, luminous, transparent and pellucid' water that is said to be found there in such great abundance and possessed of the most 'vitalising, animating, exhilarating, resuscitating, enthusing, sustaining and rejuvenating' properties imaginable, they have missed a rich treat...

In 1903 Mr George Brumfitt of Ilkley came up with a more interesting and less theatrical visitor attraction to be installed outside White Wells. He proposed to install a 'Viewstation' in the vicinity of the building and to supply information cards accompanying it pointing out different features to be seen across the valley below. The proposal was considered and approved by the council with Mr Benson remarking that they were indebted to Mr Brumfitt for the idea. The 'Viewstation' itself was a simple

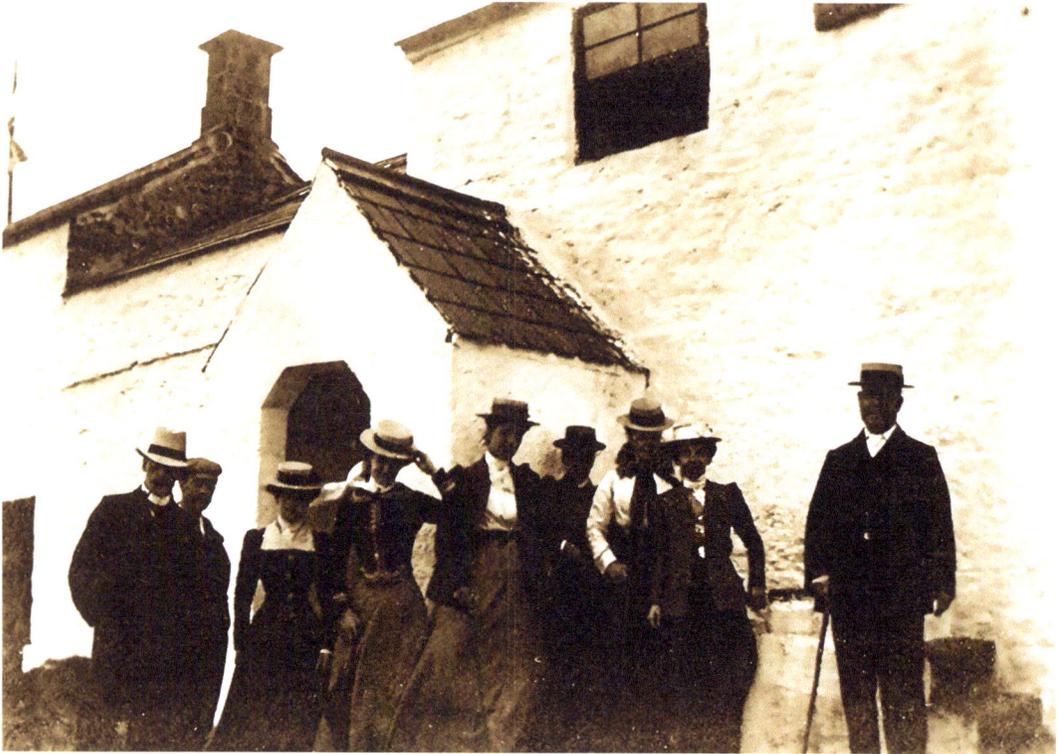

The clothing fashions may have changed since this picture was taken, but the exterior of the building remains much the same. (Sally Gunton)

direction post approximately 2.5 metres (8 feet) high, which was to be situated 'in no place that it would be an eyesore'. It was positioned outside the front of White Wells. The cards accompanying it were updated from time to time to reflect the different additions to the landscape below.

The 'Viewstation' remained outside White Wells for many years. It was replaced in 1935 after being blown down in an autumn gale and survived until the appalling levels of vandalism wrought on the building in the early 1970s. When the property was renovated by Eric Busby a few years later, the 'Viewstation' was not replaced in its original location. Instead a freestanding metal flagpole was installed to the east of White Wells.

In 2010 a new direction marker, modelled on Mr Brumfitt's original 'Viewstation', was replaced in the original spot outside White Wells by Bradford Council.

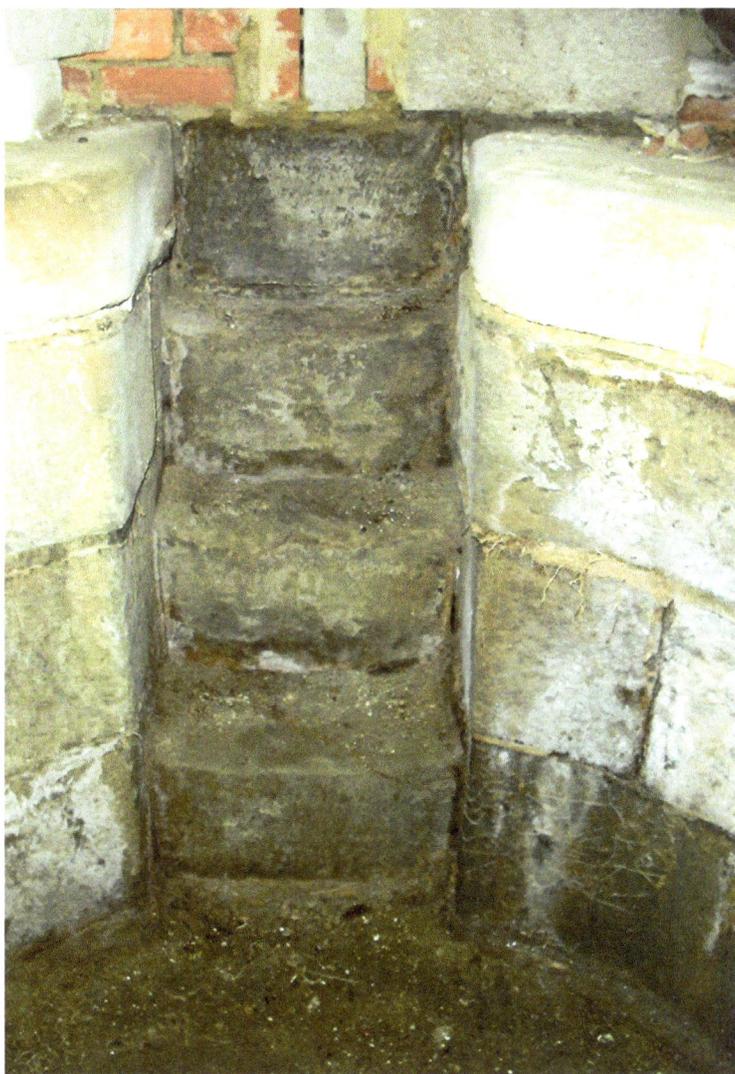

Underneath the floor of the White Wells café (reminiscent of the Victoria Hall bath but on a smaller scale) is a second plunge bath. Disconnected from the water supply when the building was renovated in the 1970s, the water depth would have been approximately 1.1 metres (3 feet 6 inches) when filled – as opposed to the 1.4 metres (4 feet 6 inches) of the more familiar display bath. (Mark Hunnebell)

The restored 'Viewstation' direction marker outside White Wells today. (Mark Hunnebell)

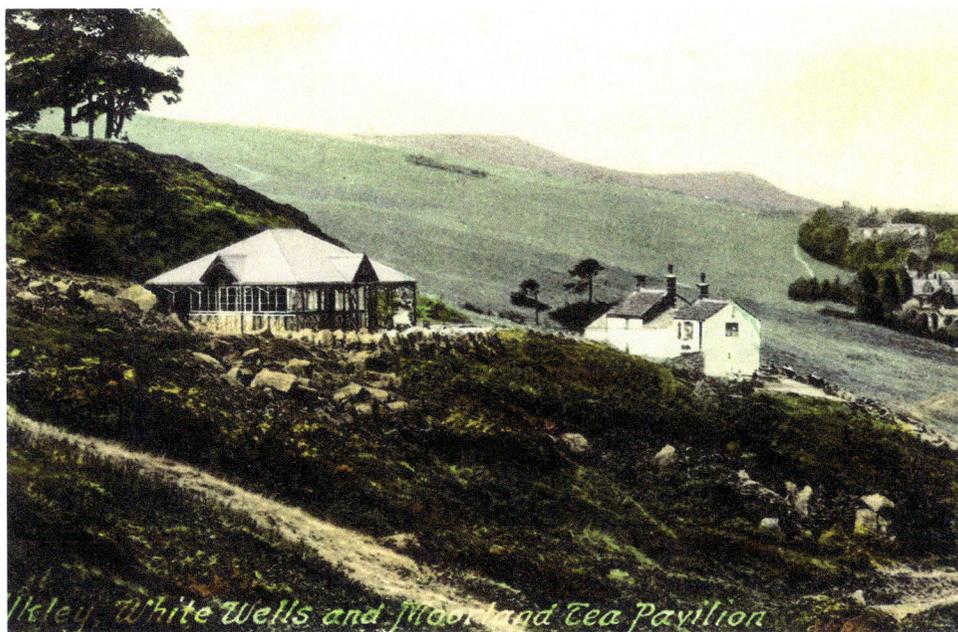

The Moorland Tea Pavilion. Early morning visitors came to the pavilion on 29 June 1927 to have breakfast and watch the solar eclipse – perhaps the busiest Wednesday morning the café experienced! (Sally Gunton)

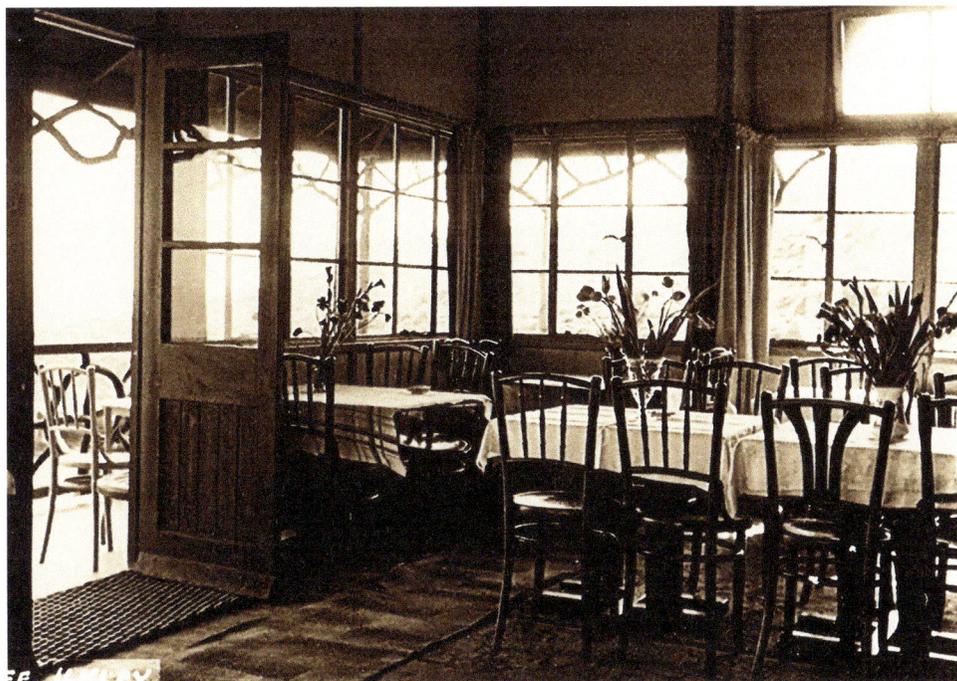

The interior of the Moorland Tea Pavilion. (Sally Gunton)

A modern photo of the pavilion taken from the same position as the previous picture. (Mark Hunnebell)

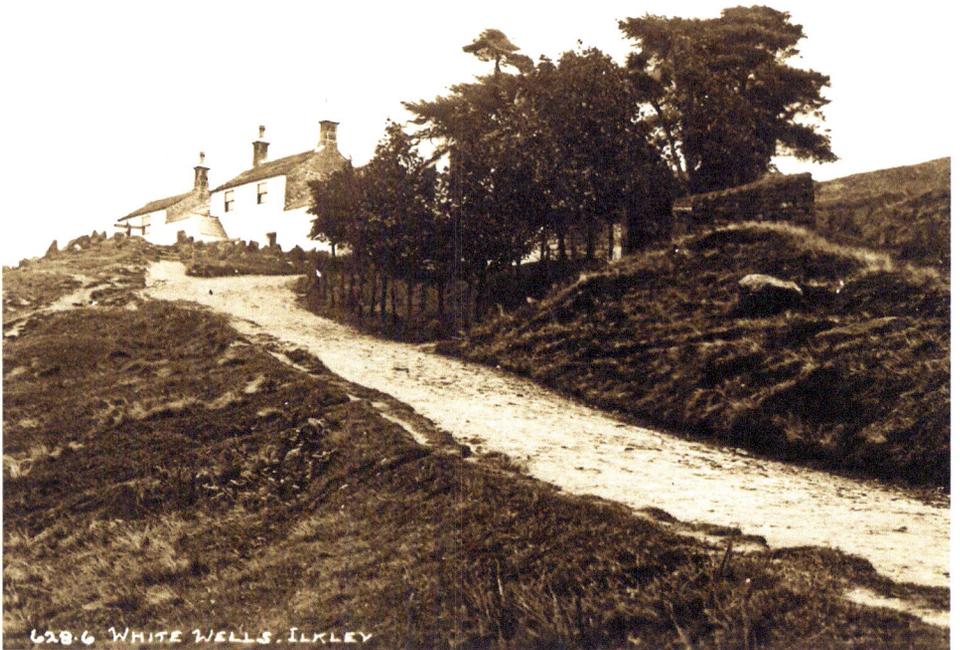

628.6 WHITE WELLS. ILKLEY

White Wells, *c.* 1910. (Sally Gunton)

DID YOU KNOW?

The rock used for the Ilkley Armistice Memorial came from the moors close to White Wells. It can be seen in the centre right of this photograph dating from around the 1910s. Just over a century later it was moved to the town's Memorial Gardens on the Grove and a plaque was attached dedicated to the serving men of the Ilkley area who survived the conflict.

The Ilkley Armistice Memorial. Ilkley is unusual in that not only is there a cenotaph to the men who died in the First World War, but also an Armistice Memorial dedicated to the men who survived it. (Mark Hunnebell)

The Tarn

Craig Dam was a marshy area of moorland that was used to supply water to the mill pond in Wells Road, which then fed the workings in Mill Ghyll lower down the hill towards the centre of town.

On the evening of 23 August 1873 a meeting of local gentlemen was held in the Crescent Hotel to discuss suggested improvements to extend the Craig Dam, with a view to making the area a pleasant place to visit and sit beside. Permission for the work was granted and money was raised through subscription. By the end of the year much of the work had been carried out and it was announced in the *Ilkley Gazette:* 'This sheet of water formerly known as the "Craig Dam" has changed its name and will henceforward be known as "The Craig Tarn".'

It was anticipated that the Tarn would become a popular attraction with both locals and visitors to walk around in summer and to skate upon in winter.

A decorative fountain fed by gravity from a supply further up the moor spouted water high into the air. This feature was later removed, though the island remained, providing a home for ducks and other waterfowl. As anticipated, ice skating became a popular winter activity at the Tarn. The local press enthusiastically reported on it – and the results of hapless individuals venturing onto thin ice and ending up knee deep or more in cold water!

The Tarn. (Mark Hunnebell)

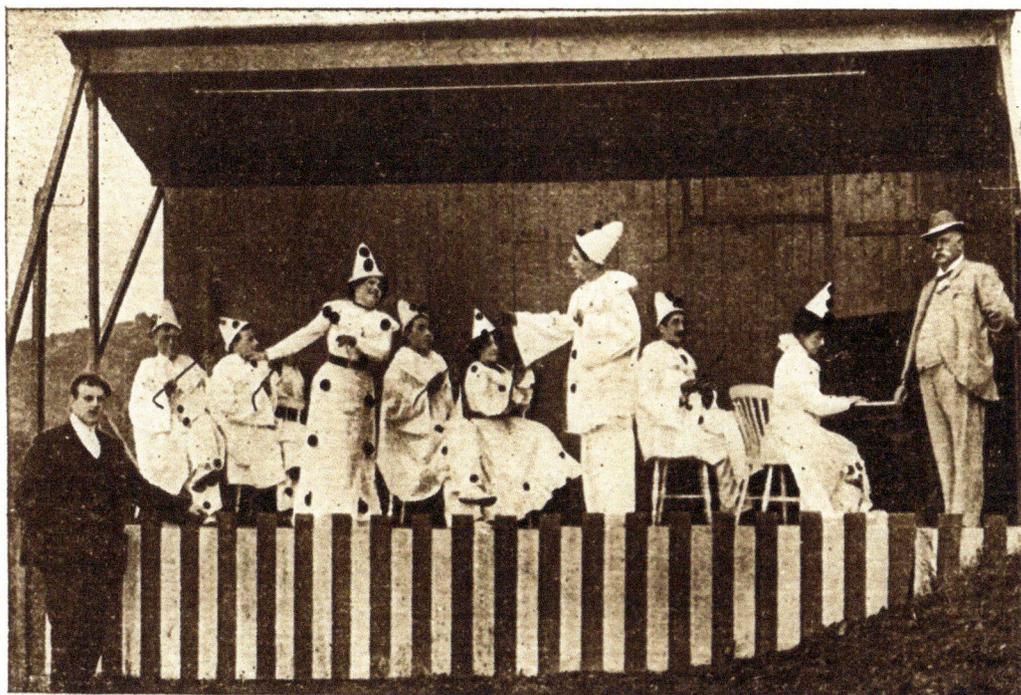

Cooper's Tarn Pierrots Ilkley " In My Little Canoe " H. Cooke. Photo . G

Cooper's Tarn Pierrots perform *In My Little Canoe*, a catchy turn-of-the-century ditty from America. (Sally Gunton)

In 1881 the Tarn Band was formed and they played selections for the entertainment of summer visitors. During the early years of the twentieth century the PSA movement, which was affiliated to the Congregational Church, had established a presence in Ilkley. In 1903 it was reported that during the summer they would hold meetings at the Tarn.

By 1904 Pierrot performances had become a popular attraction at the Tarn. A purpose-built stage and adjacent dressing room was built by Mr Cooper and this caused considerable controversy. Pierrot performances were deemed by some to be too vulgar, having more of an element of cheap seaside entertainment about them. Consequently Mr Cooper had to remove his stage following the 1905 'season'. The bandstand that had been built in West View Park proved increasingly popular instead, and was considered a more appropriate form of entertainment.

However, meetings were still held at the Tarn. Mrs Pankhurst visited Ilkley on 8 June 1908 and led a well-attended gathering there. There were minor interruptions from within the crowd, consisting of 'bell tinkling, music hall ditties, penny trumpets and a bugle...' Bell tinkling had been used by the suffragettes themselves when they wished to disrupt meetings in their own campaigns. They evidently didn't take kindly to the same tactic being used against them by a small element in the crowd at the Tarn. Overall though the meeting passed peacefully and the women got their point across.

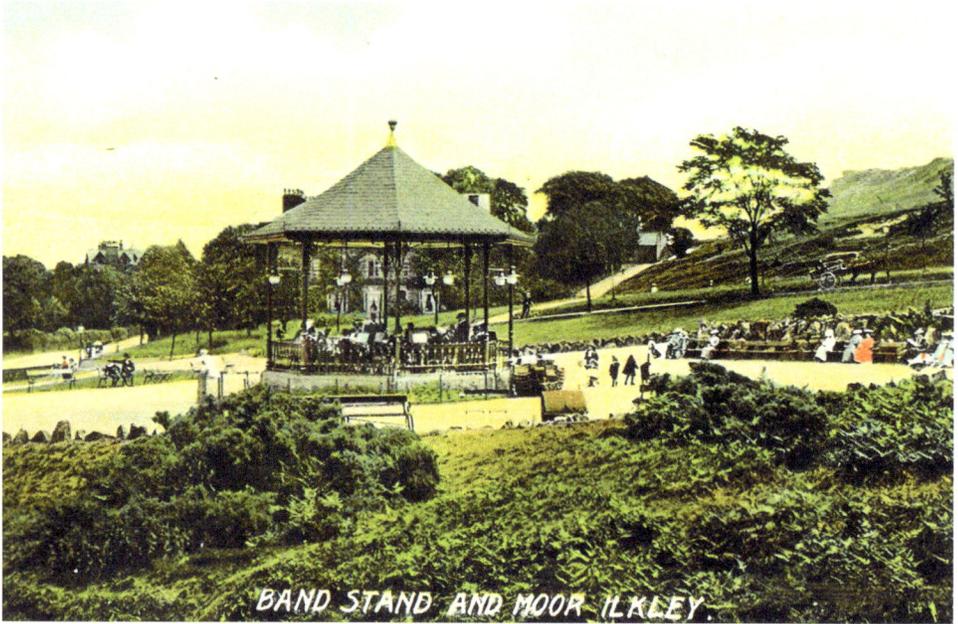

The bandstand in West View Park. A shelter was built nearby in 1911. Today this area is the Darwin Gardens Millennium Green car park. (Sally Gunton)

Darwin Gardens Millennium Green. Originating from an idea by local historian Frazer Irwin, Ilkley's Millennium Green was opened by a former town resident, author Jilly Cooper, on 24 June 2000. (Mark Hunnebell)

The Cuckoo Hut overlooking the paddling pool. (Mark Hunnebell)

The paddling pool today, catching the reflection of Hillside House, where Charles Darwin stayed for some of his time in Ilkley in 1859. This building is perhaps better known more latterly as St Winifred's, a maternity hospital where many Ilkley residents of a certain vintage (including myself) were born. It closed in 1971 to become an annexe of the Ilkley College until 1999 and has since been converted to residential use. (Mark Hunnebell)

Santa Clause at the paddling pool in December 1934 demonstrating toy boats for Busby's department store.

Along the northern side of the Tarn a wooden shelter was built in 1912. Originally this contained glass panels and was modelled on the shelters at Saltburn-by-the-Sea. The 'Cuckoo Hut', as it became known, has been repaired and rebuilt over the years and its modern incarnation still provides a pleasant place to sit and watch the world go by. Another similar shelter was built at the top of the steps overlooking Hainsworth's Pond. The pond was made into a paddling pool in time for the start of the 1927 'season'.

The lighting at the Tarn along the access road up to it from Wells Road was installed at an estimated cost of £165 by the council in 1931. Before then arc lamps had been used as a temporary source of illumination for skaters in the winter, but the Ilkley Council wanted something more permanent.

After many years of disuse the lamps were reinstated in 2007 with modern fittings and in 2009 the more traditional-style lanterns now in use were installed.

The Ilkley Moor Golf Course

In 1890 the possibility of establishing a private golf club and the feasibility of locating the course on Ilkley Moor was being examined. On 5 June the Ilkley Golf Club came into existence at a meeting held at Wells House, and a nine-hole course was laid out on the moor. As we have seen in the previous chapter, the club moved to a new course north of the river in 1898, and the moorland course became the Olicana Golf Club. The name was changed to the Ilkley Moor Golf Club in 1905.

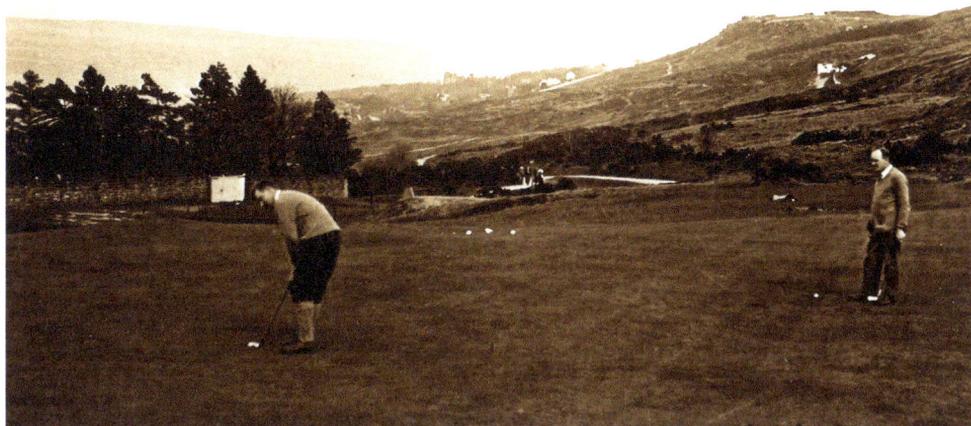

The Ilkley Moor Golf Course. (Sally Gunton)

The moor course was later extended to eighteen holes. Work began in 1913 but was interrupted by the First World War the following year, eventually being completed in 1916. The course would have dominated the view west from White Wells towards Hebers Ghyll and Addingham Moorside.

Following financial difficulties the club was renamed the Ilkley Moor Golf Club 1939 in that year to differentiate it from its predecessor. The council had a keen interest in retaining the course but without the added maintenance of a clubhouse and carried out the necessary groundwork. The council stopped short of making it a municipal golf club and despite proposals for the course to be fully re-established following the Second World War sufficient interest and means were not forthcoming, likewise another revival plan forwarded in the early 1970s. The course has subsequently been reclaimed by nature – leaving subtle traces that can still be seen today.

The 'Bull Rock'

The 'Bull Rock' holds an almost mythical place in local history. Even its existence has sometimes been questioned. It was held that it was located on the moors near to the Cow and Calf Rocks unsurprisingly, given its bovine appellation, but unfortunately there doesn't seem to be any early photographs to confirm this. It appears that the rock did exist though. An interesting article about it, taken from the *Leeds Mercury,* appeared in the *Ilkley Gazette* of 11 February 1899, which also challenges a popularly held belief among the good folk of Ilkley:

Below the two huge rocks known as 'The Cow and Calf stood a rock larger than the Calf, which was known as the 'Bull'. It was much nearer the highway than the Calf, but had

evidently, like its companions, slipped away at some remote period from its original bed... It is said that the Crescent Hotel is mainly built from this stone so some idea may therefore be formed of its vast size and proportions...

The *Gazette* concludes the article by stating:

> For the information of our readers, we may state that the popular held belief that the Crescent Hotel was mainly built of stone cut from this huge rock is incorrect; it was the three private houses above the railway bridge in Brook Street, and belonging to the Midland Railway Company that were built from the 'Bull'.

So contrary to popular belief, it was not the Crescent Hotel that was built from the stone of the Bull Rock.

Two of the houses at the top of Brook Street were demolished when Woolworths was built in the late 1930s. The remaining property, which had been in use as a shop (Greenwoods gents' outfitters), was demolished in the 1980s, along with the shops on the corner, as part of the railway station redevelopment.

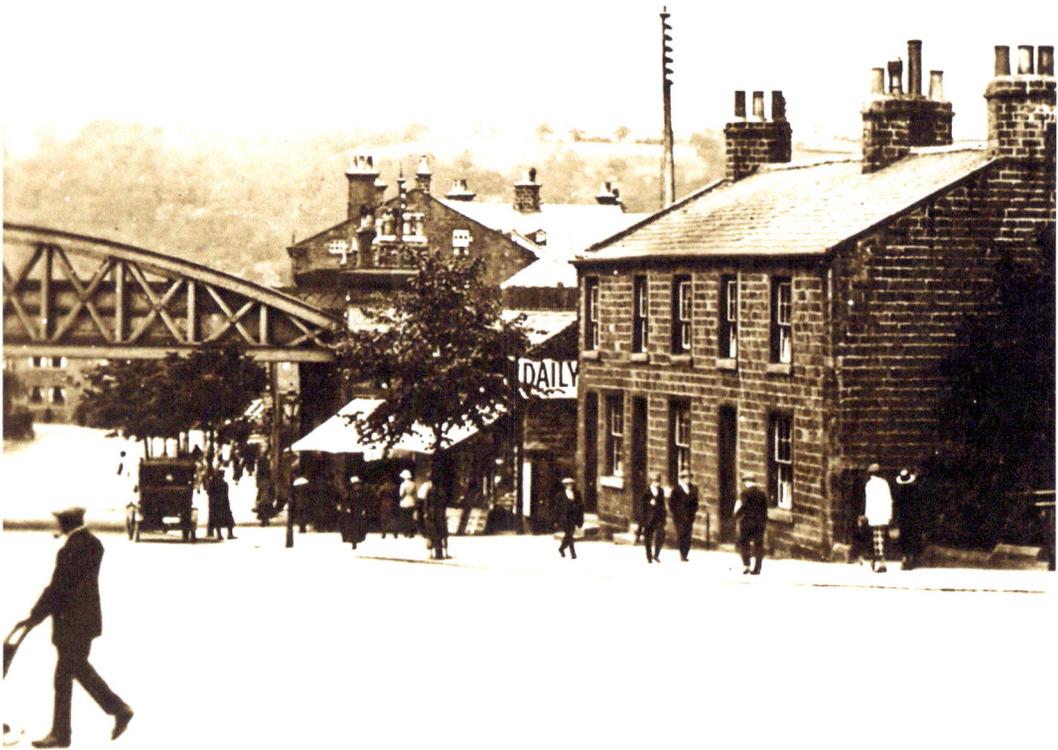

The former houses at the top of Brook Street, which were built from the stone of the 'Bull Rock'. (Sally Gunton)

Hangingstone Quarry

Quarrying at Hangingstone had been going on since the early 1870s and by the end of the first decade of the twentieth the activity was attracting more than a little controversy. There were demands for it to be stopped before the moors became irreversibly defaced. In 1908 the council debated the issue and decided the work should cease. One of the councillors, Isaac Dean, abstained in the vote. He was the quarry owner and in 1909 and 1911 he also served as chairman of the council.

There was a great deal of debate over the terminology of quarrying and quarried stone. The former term was applied to the actual digging out of the stone and the latter to stone that had already been removed from the rock face. Consequent to this, quarrying stopped but it took a couple of years to dispose of the quarried stone stored at the site.

Hangingstone Quarry. Situated to the west of the Cow and Calf Rocks, there is little evidence remaining today of the industry that was undertaken here. The exposed rock faces to the east of the site bear testament to a later activity: target practice. The former quarry was used as a firing range by the military during the Second World War and there are bullet holes all over the rocks. (Sally Gunton)

The view of the former quarry today. (Mark Hunnebell)

The 'Big Bang' of 1974

The peace of Ilkley was disturbed on 15 September 1974 when a loud explosion was heard across the town. Initially something of a mystery, the *Ilkley Gazette* reported on the occurrence in the 20 September edition:

> The Big Bang around about 8.40 on Sunday night brought a great many people at the western end of Ilkley and on to Ben Rhydding out of doors. There was nothing to suggest the cause. Houses had been shaken, windows had been rattled, and in every case people thought something had happened in their immediate vicinity...

There was no evidence of supersonic aircraft in the area or anything else to indicate the cause. In the following week's newspaper, more light was thrown on the mystery:

> An Ilkley man suggests that the 'Big Bang' was caused by an explosive charge placed in one of the foot-holds up the side of the Calf Rock on Ilkley Moor. Some of the foot-holds have been obliterated and there was debris in the vicinity.... The only other possibility is that the rock has been struck by lightning.

The culprits have never been found. Clearly the Calf Rock stayed in place despite the blast and didn't either break up or start rolling down the hillside with disastrous consequences. We can only speculate as to whether this was indeed the objective of whoever planted the charge.

Weighing an estimated 1,500 tons, it is fortunate that the Calf Rock stayed in place when an explosive charge was allegedly detonated in one of the footholds in September 1974. This photo, dating from the early twentieth century, illustrates the scale of the rock by the people on top of it. Their canine companion is also enjoying the view from up there! (Sally Gunton)

With this in mind, we are drawn to a *Gazette* article from 19 February 1910:

The Weight of the Calf Rock.

A number of gentlemen resident at one of the Ilkley Hydros, a day or two ago had a discussion in respecting the weight of the Calf Rock. The weight was variously estimated at 15, 50, 100, 200, 500, 1000, and 3000 tons. The latter was regarded as an extravagant estimate, but calculating that there is as much rock buried as appears on the surface, it turned out to be a remarkably good calculation. By measurement it was found that allowing for dints and inequalities the weight of the rock above ground was about 1,500 tons.

DID YOU KNOW?
The 'Premium Bonds' draw on 1 April 1958 saw the number selection computer 'ERNIE' being activated remotely from the Cow and Calf Rocks. The winner, from the Manchester area, claimed a prize of £1,000.

DID YOU KNOW?
From a particular angle to the side of the Cow Rock it appears that this familiar landmark is looking out across the Wharfe Valley.

The Cow Rock. (Mark Hunnebell)

The Swastika Stone

The Swastika Stone is one of the most well-known carved rocks on the moor and has been speculated on in the local press many times, including this from the *Ilkley Gazette* of 5 April 1913:

> Ilkley's famous Swastika Stone. The above is a representation of the Swastika markings on a large rock situated on Woodhouse Crag, a little to the west of Hebers Ghyll. It is the only specimen of the curled form of the design met with in England, and very rare. This example is believed to belong to the Bronze Age, and is similar to markings on rocks and bronze ornaments found in Sweden and Greece. The swastika is believed to be an early symbol representing 'fire', and was used all over Europe, as well as to this day in India, as a sign of good luck and to avert the evil eye and other misfortunes.

The accompanying photograph in the paper is of too poor a quality to reproduce, so a modern photo is shown instead and is orientated, like the *Gazette*'s original, with north at the top. Another perhaps overlooked possibility for the Swastika Stone is that it may be Roman in origin – much later than many theories. The article mentions swastikas in Sweden and Greece, and there is another example at Sellero in Italy, very similar to the Ilkley stone, also attributed to the Iron Age. Interestingly, serpent and horse-head swastikas were often used by Roman mounted divisions. Although no other swastika motifs have been found in excavations of the Roman fort site in Ilkley, jewellery with

The Swastika Stone is easy to find as it sits on the edge of the escarpment with iron railings on three sides. Much has been speculated and written about the mysterious swastika-shaped markings on the rock. (Mark Hunnebell)

swastika designs dating to the era have been unearthed in other parts of the country. Could it be that a group of riders passing through or temporarily based at Olicana stopped off at Woodhouse Crag and indulged in a little graffiti? This may also explain the one-off nature of the Swastika Stone. I'm not suggesting that the Swastika Stone is Roman, but that it may be.

There are many other examples of cup- and-ring-marked rocks on Ilkley Moor that almost certainly predate the Roman period. Theories abound as to their significance and purpose, from burial mounds to waymarkers, sacrificial altars to star maps and even landing sites for alien spacecraft!

The Badger Stone on open moorland above Spicey Ghyll is another example of ancient markings. Some of these might predate the Swastika Stone, while some of the markings are a little more recent. Although the Badger Stone was included in a list of ancient monuments in 1930, sixteen years later in 1946 it was mentioned in the *Ilkley Gazette* that some of the markings were caused by firing practice on the moor during the Second World War, from machine gun fire. The paper speculated this may cause confusion to future historians.

The Badger Stone. (Mark Hunnebell)

Cowper's Cross. (Mark Hunnebell)

Near the top of the moor at Keighley Gate stands Cowper's Cross, an ancient boundary marker. It was struck by lightning in June 1931 causing considerable damage, but was soon restored. A story printed in the local press at the time gave a speculative view that in times of plague, Cowper's Cross was used as a depository for supplies so as to prevent direct contact between communities.

The Cairn

As part of the coronation celebrations in 1953 the pupils of Ilkley Grammar School rebuilt the Cairn on Ilkley Moor. Incorporated into the base was a casket containing artefacts of the day. Unfortunately the Cairn was vandalised five years later:

> It must have taken quite some time for those responsible to demolish the heap of stones on the skyline which Ilkley Grammar School pupils erected as a Coronation gesture five years ago. If the scouts re-erect it, as they are thinking of doing, it is their intention to put up a much more substantial heap of stones and to restore it nearer to its original site. The Grammar School chose a point slightly to the east of the original heap and to tidy minds as seen from the town this was distinctly off-centre.

The work was undertaken by the scouts to mark the fiftieth anniversary of the first meeting of Scouts in Ilkley in October 1908. The following summer, in July 1959, the pupils of the Ilkley Grammar School rebuilt their cairn. However, by October it had been vandalised again. The facts reported in the local paper suggest that there were two cairns on the moor in close proximity to each other. Indeed today there is a smaller pile of stones around 100 metres east of the cairn rebuilt by the Scouts in its more aesthetically pleasing and not 'off-centre' location on the ridge above Ilkley Crags.

DID YOU KNOW?
Westwood Lodge on the edge of the moor was once the family home of Herbert Ponting, the photographic artist on Captain Scott's Terra Nova Expedition. The property was owned by Herbert's father in the early years of the twentieth century. Today Westwood Lodge provides self-catering cottages and residential accommodation.

DID YOU KNOW?
The carved rock in Panorama Woods is a representation of the nineteenth-century Prime Minister W. E. Gladstone. According to the *Ilkley Gazette* in 1939, the carving was made some fifty years previously in the 1880s at the height of Gladstone's career – though why it was carved isn't explained.

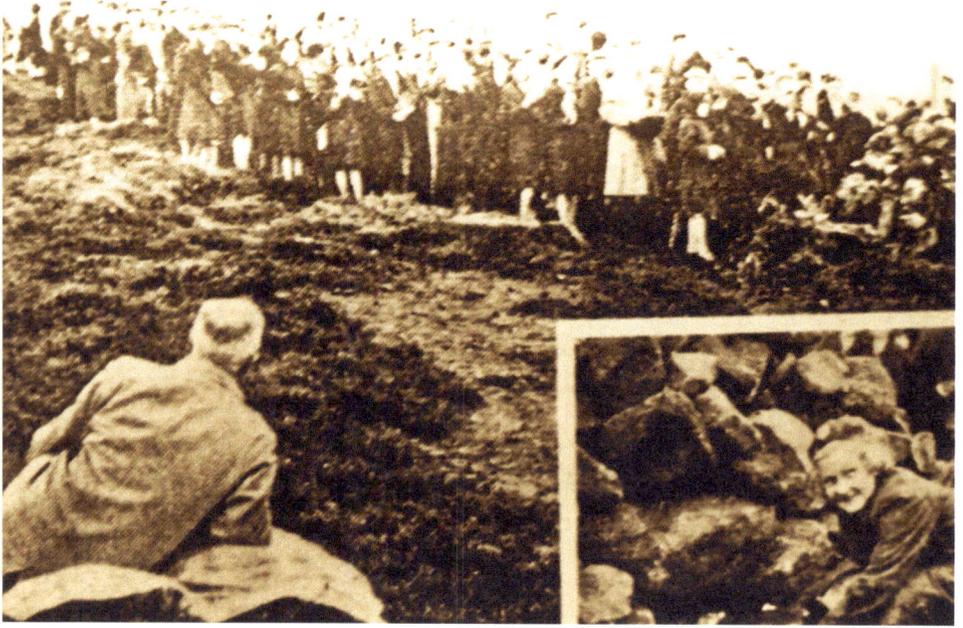

Ilkley Grammar School pupils placing a casket at their newly rebuilt Cairn in 1953. Pat Cookson, the school's youngest pupil (inset), does the honours. (*Ilkley Gazette*)

Gladstone Rock. (Mark Hunnebell)

Westwood Lodge. (Mark Hunnebell)

5. Miscellaneous

Fish and Chips

A curious matter for the Local Board came before them in the summer of 1892. We tend to think of fast-food vans being something of a modern invention, catering for late-night revellers on their way home from the pub. It seems the concept has been around a little longer than we might have thought. This from the *Ilkley Gazette* in July 1892:

> The Fried Fish Van.
> A petition from residents in Church Street and vicinity was read complaining of a nuisance caused by a fried fish trade being carried on in a caravan situated in Church Street, on land adjoining the old vicarage, by Mr Greenwood of Burley-in-Wharfedale...

Mr Greenwood stated that 'If anybody could prove that any smell issued from it he would give them £20.' He also suggested that 'With the Local Board's consent he would remove the van into the yard at the back out of sight.' However, 'On the motion of Mr Illingworth, seconded by Mr Ellis, it was resolved that the building be removed forthwith.'

A similar report appeared in the *Gazette*'s rival newspaper, *The Ilkley Free Press and Addingham Courier* with a reference to the 'Fried fish and chipped potato nuisance'. These reports put the availability of fish and chips in Ilkley back into the early 1890s, rather than a more commonly supposed twentieth century arrival in the town.

Unfortunately nobody seems to have photographed Mr Greenwood's early entry into the fast-food market.

Fish and chips gained in popularity and by the start of the First World War had become a regular feature of the British diet that had been even been noted overseas. For example in May 1915 it was reported in the *Gazette*:

> One writer described the loss of personal belongings on the way to the Front, but evidently found a good deal of comfort and consolation in the fact that they stopped for a time at a place where there was a 'fish and chip' shop, a welcome 'bit of Old England' for many; though a rather strange sort of business to carry on 'amid the sounds of battle'. Evidently the proprietor was a man of enterprise, and knew what the British 'Tommies' liked.

In the early days of the Second World War, the supply of fish was threatened. The *Gazette* reported on 22 September 1939, less than three weeks after the start of the war:

> One of the trades affected the earliest by the war has been the familiar one of fish and chips, and the many shops in Wharfedale and Airedale have been in no better position

than those elsewhere ... Lately, however, fish has undoubtedly been scarce, and the tasty 'tail and two pennorth' has been all the more clamoured for because of its absence...

After the Second World War and before the arrival of alternative fast foods, fish and chips continued to be popular and there were a number of establishments in Ilkley catering for the demand. In 1967 an application was made to the IUDC for a chippy to be opened at the bottom of Mornington Road. There was considerable objection to this, not least from those living nearby, but an application in the early 1970s for another shop to be opened around the corner in North Parade was passed. Perhaps because Mrs Earnshaw's former business there, although closed for a number of years, had provided a precedent for a fish and chip shop in this street. Chip-E-Walkers, the shop that opened, proved very popular, taking over the original shop and the house next door. The business became Lees later in the decade. More recently after downsizing back into one property the shop survives today as North Parade Fisheries. Other chip shops in the town included West End Fisheries on the corner of Church Street and Bridge Lane; Thorntons in New Brook Street; Barkers on the corner of Leeds Road and Weston Road; Moorview Fisheries on Leeds Road (known colloquially as 'Tin Plate' owing to the fact that the fish and chips were banged out of the fryer onto an enamel plate prior to being wrapped up to take home), now rebranded as Grandad Nichols; Colbert Avenue, since converted into a Chinese takeaway; and the 1970s institution The Fish Dish in Brook Street, opening up where the Thrift supermarket had been in the early 1960s, a site since extended and now home to Boots. More latterly, apart from the many restaurants and wine bars in Ilkley, other fast-food shops remain popular, serving pizza, Chinese, and Indian dishes (and also another excellent fish and chip kiosk at the Riverside Hotel in the park). In the 1980s, 1990s and early 2000s a mobile fast-food van serving burgers, chips and kebabs parked up on the central car park at weekends to serve late night customers on their way to and from 'The Trav'. Mr Greenwood, perhaps, would have been proud!

The 'Great Flood' of Ilkley

On the afternoon of Thursday 12 July 1900 a colossal storm broke over Ilkley Moor. Following days of dry, hot and oppressive weather, the ground had become very hard. The cloudburst was accompanied by thunder and lightning of a spectacular magnitude and water poured off the moor, overwhelmed the stream courses and flooded the town. The moors on the northern side of the valley were largely unaffected by the storm, although there was rain. The devastation was caused by localised water flowing from Ilkley Moor and through the town. The river was quite low following the days of heat and didn't burst its banks. The *Ilkley Gazette* of 14 July naturally dedicated several columns to the flood:

The rain came down so heavily and persistently that a half hour saw Brook Street and other thoroughfares turned into gigantic mountain torrents. The basements of many houses and places of business were flooded and in numbers of instances valuable goods and stock were either damaged or completely spoiled ... The greatest destruction was wrought along the line of the three principal streams having their source on Ilkley Moor... while the channels worn by the rush of water measured as much as a yard or two yards in depth and several yards across...

Along Chapel Lane the force of the water undermined the foundations of a coach-building workshop, causing it to collapse. Tragically Alfred Brogden was working there at the time and was killed.

The *Gazette* published a special supplement showing photographs of the destruction at different points around the town and the following week the paper of 21 July reported further on the flood and its aftermath and the inquest into the death of Alfred Brogden – and on the antics of visitors who had travelled to Ilkley simply to view the devastation:

> To outsiders the scenes of devastation have afforded interest in abundance, and each day has seen crowds of trippers inspecting the ruins. The rubbish heaps at the back of dwelling houses they have likewise visited, and anything worth pocketing has been conveyed home as a memento of the disaster ... Trippers always find the humorous side, go where you will, and it has been no uncommon experience on the part of those busy clearing water and mud out of their houses to find themselves, instead the objects of commiseration, a very unpleasant butt for the ignoramuses no law has yet given power to keep under lock and key.

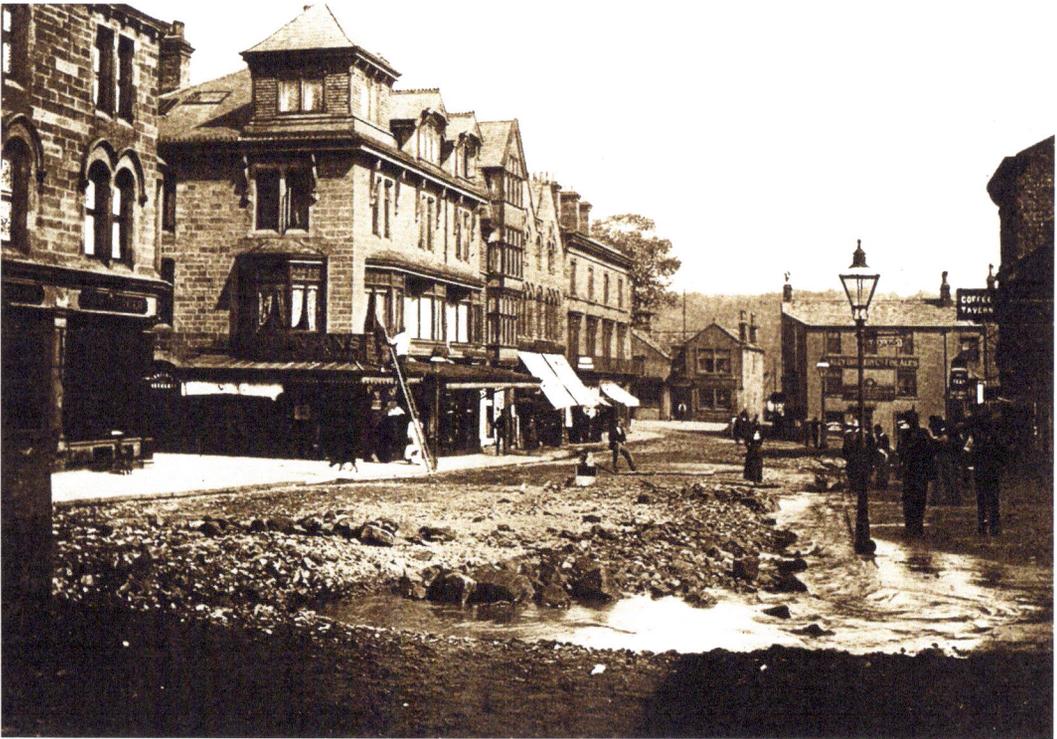

Damage caused by the flood was extensive. Rocks and sand were washed down from the moor and deep channels were cut into the streets. Wray's Pleasure Garden on Bridge Lane was completely deluged and Brook Street suffered considerable damage too, with the culvert carrying water from Mill Ghyll to the river bursting up through the road. A big clean-up and repair job lay ahead. (Sally Gunton)

Understandably the paper doesn't record the replies of those on the receiving end of the thievery or jocular comments.

The Horse Trough at the Top of Brook Street

It would be easy to dismiss the horse trough as something that had stood at the top of Brook Street since Donkey Jackson was a lad. The fact is that he didn't live to see it, dying at the age of 81 in 1907. The idea of installing a horse trough had been suggested by the council in 1908. Early the following year estimates had been obtained and it was reported in the *Gazette* of 6 February 1909:

> ...that the tender of Mr H. Hutcheon, Aberdeen, (£31), for the supply of a granite horse trough, six feet in length, intended to be fixed at the top of Brook Street, be accepted...
>
> Mr Wilkinson thought the bottom of Brook Street was the most suitable place for the trough.
>
> Mr Mott spoke in favour of the top of Brook Street and eventually the amendment was defeated and the minutes passed as read.

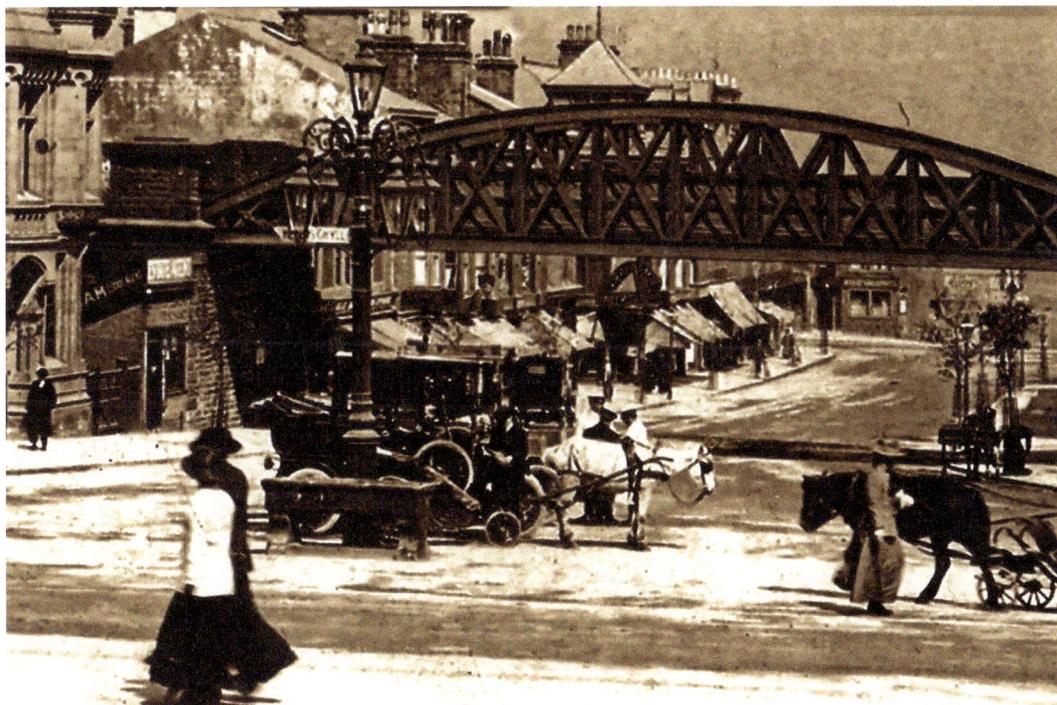

Looking down Brook Street, *c.* 1910. The horse trough and a new ornate street lamp have made their appearance. (Sally Gunton)

After many years in the Golden Butts Road Council Depot, in 1983 the horse trough was moved to New Brook Street, where it now serves as a flower planter. (Mark Hunnebell)

So the Brook Street horse trough came into being. Just at the time that motor transport was in the ascendancy. The trough remained in place for just over twenty-two years. By the early 1930s cars had, for the most part, replaced horse-drawn transport and there were road traffic improvement plans afoot. It was proposed to build a traffic island at the top of Brook Street, which would mean the troughs removal. The *Gazette* reported on the council meeting in December 1931:

> Dr Whitfield, Chairman of the Public Health and Highways Committee, called attention to the intention to remove the horse trough at the top of Brook Street in connection with this proposed 'island'. The trough had served a very useful purpose in its time, he said, but there were very few horses needing it. Mr Sugden said that if they took the trough away he hoped they would make provision to use it and suggested that it may be placed in the motor park so that people could use it who need water for their engines.

Public Transport

The railway connections were, of course, one of the biggest advances in the local public transport infrastructure, but in the early years of the twentieth century motorised road transport started to make its presence increasingly felt, with charabanc outings to Bolton Abbey and other destinations up the Dales being popular. In 1911 another type of

public transport was proposed for the area: 'Trackless Trams'. Trolleybuses were being introduced in larger towns and cities and it was felt that such a scheme would be beneficial in Wharfedale to connect Otley to the Leeds tram network that had its terminus at White Cross, Guiseley. Services started in 1915 and it was soon decided to extend the scheme as far as Burley-in-Wharfedale. The plan to extend as far as Ilkley never came to fruition. It was felt, particularly by a number of the town's traders, that to have another form of transport available would tempt customers away from Ilkley. It didn't seem to persuade them that more visitors, and by extension potential customers, could be attracted to Ilkley from other areas, so the 'Trackless Trams' stopped at Burley-in-Wharfedale.

The trolleybus services were withdrawn in the mid-1920s and the overhead wires dismantled. By that time motor bus services were providing stiff competition for the trolleys, as buses were not restricted to particular routes but could go much further afield and connect many other places.

The legendary Ledgard's bus company operated services on popular routes in the area between the 1920s and the 1960s. Crowds of bank holiday visitors would queue in New Brook Street to head back home to nearby towns on the famous blue and cream buses. When not in service the vehicles ending their runs in Ilkley were kept in the Nelson Road depot off Little Lane. Ledgard's was eventually absorbed into the West Yorkshire Road Car Co. in the 1960s. The Nelson Road garage survived until 1982 when it was demolished to make way for housing. However, a small portion of the brick building remains, as a perimeter wall of a parking area.

Ledgard's bus garage, Nelson Road. (Sally Gunton)

Drinking Fountains

During the Victorian era great strides were made in the supply of water to homes. In Ilkley a reservoir had been built on the edge of the moors in the 1850s, and pipe networks laid out as the village evolved into a town. The availability of fresh drinking water was a matter of great civic pride and as the town developed, public drinking fountains were installed by both the Local Board and philanthropist endeavours.

Following a complaint about the perceived lack of drinking fountains in Ilkley, the *Gazette* was keen to set the record straight and printed a feature as to where they could be found. This from 27 August 1904:

> Drinking Fountains. A visitor in a letter to the Editor points out the need of drinking fountains in Ilkley and what a boon such would be to the public. Fountains, or at any rate places serving the same purpose, do already exist in Ilkley and in proof of this we append the following list of places where a draught of chalybeate or ordinary water may be obtained: White Wells, Crawley's Fountain on the footpath leading to White Wells, The Tarn, Keighley Road (a little above Wells House), Keighley Road (near summit of moor), top of Heber's Ghyll, half way down the Ghyll, Public Gardens, top of Cunliffe Road, Mill Ghyll, and near the Brewery, Railway Road.

All the fountains except one are no longer in use and in many cases no trace of them remains. The last drinking fountain and also the earliest is situated behind White Wells on the moor. Water passes through filters inside the building to comply with modern health regulations and back out to the fountain. The water is therefore safe to drink. Contrary to popular belief, the fountain at White Wells has never dispensed chalybeate or iron water.

Meanwhile another fountain awaits rediscovery. In 1883 it was constructed on a cobbled area laid out to south of the Old Reservoir down the moor from White Wells. This was funded by a Mr Crawley, who wanted to provide facilities for those too infirm to make the

The White Wells drinking fountain. (Mark Hunnebell)

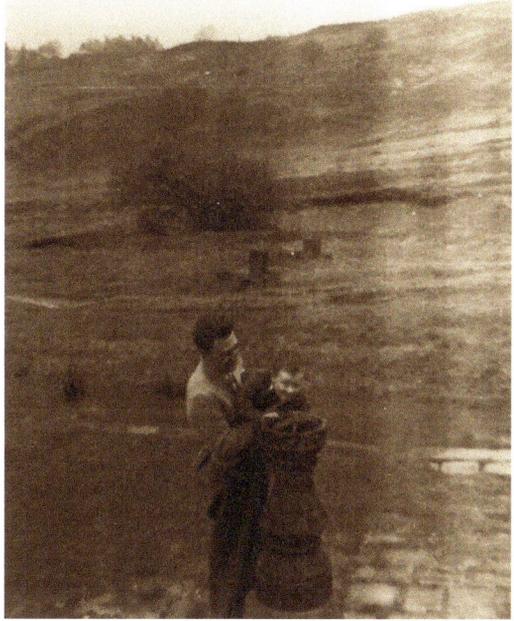

Right: Crawley's Fountain. (Mark Hunnebell)

Below: The Canker Well on the Grove used to dispense chalybeate water. Modern health and safety requirements preclude the consumption of this and the fountain is now dry. (Mark Hunnebell)

journey to White Wells. Water was piped down from the spring. On the 8 September there was an impressive opening ceremony. The Union flag was flown and a crowd gathered to see the fountain, give three cheers and sing the national anthem. By 1967 the fountain had been dry for about a decade. The photograph shows me at three years old being lifted up by my dad to take a closer look! Apparently Crawley's Fountain was buried under a large mound of earth following the construction of the nearby reservoir, which was completed in 1970. As far as is known, the ornate fountain remains there.

DID YOU KNOW?

In 1929 there was concern that people were allowing their dogs to use the cups attached to drinking fountains. One such incident at Hebers Ghyll resulted in condemnation in the local press after witnesses had been 'so disgusted by the spectacle that they turned away with a sense of nausea'. The paper added: 'Needless to say, the dog owners themselves did not use the cup after their dogs; they either produced their own cup or used their hands as a cup. It can scarcely be expected that the Ilkley Council can take any steps which will prevent such an abuse of drinking facilities, when the common sense of dog owners sinks to such an inferior level.' Drinking cups and, indeed, the drinking fountains of Ilkley have all but disappeared today, with the notable exception of the fountain at White Wells. This is still popular with walkers – and in some cases their dogs as well.

The Brook Street Fountain

In 1874 a proposal was made to install a decorative fountain at the bottom of Mill Ghyll and the top of Brook Street. This was completed in 1876 and there was also a drinking fountain adjacent. In 1911 there were proposals for the ornate fountain to be removed to one of Ilkley's public gardens and replaced instead 'with an inexpensive bandstand or platform where the band could play in the evening' and to provide a focal point in the town centre. However, this didn't happen and the fountain remained in place at the top of Brook Street.

After the First World War an amusing article appeared in the *Ilkley Gazette* in August 1919 quoting an observer of the characters who liked to frequent the seats around the fountain:

lkley Monkey Rack Club: The seat at the top of Brook Street has come to be known as 'The Monkey Rack' and here 'old codgers', so to speak, and young ones too, sit and discuss public matters, and anything else on the tapis. Evidently someone has been trying to poke fun at some of the frequenters of the seat, for several early this week received by post a typewritten circular requesting them to attend a meeting of the Monkey Rack Club at the Monkey Rack on Wednesday evening at 7.20. Those qualified for membership of the club were stated to be – retired tradesmen, insurance agents &c, and the objects were

given as follows:- (1) To pull from together the Council. (2) To criticise persons passing the Monkey Rack. (3) Any gossip which can be suitably dealt with by washerwomen. The circular was signed by Paul Pry, Hon, sec.

In 1956 the Rotary Club built a stone shelter at the Monkey Rack. The fountain was modified to form a cascade, because in windy weather users of the seats received a soaking. During the work a bench marker was found at the site of the old drinking fountain where the shelter was to be placed, giving an elevation of 96 metres (313 feet) above sea level. In 1959 as part of the ongoing improvements to the area, the surround of the fountain was modified and the decorative horses removed. Despite having made repeated calls for the various improvement works to be carried out, the *Gazette* reported the demise of the fountain with a sense of lament: 'This time no risk has been taken with the horses. On Tuesday morning (24th February) they were removed and in a few minutes were a heap of scrap metal alongside the site they had occupied since 1876.'

By the early 1980s the shelter had become badly vandalised and despite repeated efforts to clean up the area around the shelter, it was ultimately decided to remove it, though with a view to keeping the stone for other community projects. At the end of February 1983 the shelter was demolished and work was undertaken to tidy up the area around the Monkey Rack. It was hoped to reinstate the fountain but in place of water a floral fountain was created instead. The Monkey Rack still provides a pleasant place to sit and watch the world go by.

The Monkey Rack and Fountain. (Sally Gunton)

DID YOU KNOW?
During the First World War not all the news was doom and gloom. In Ilkley life continued and an incident was reported in the local paper in 1916 when a monkey escaped from Wray's Pleasure Gardens after being teased by young boys. The monkey made itself at home and raided the pantry of a nearby house then made a further escape to Hebers Ghyll, where an attempt at recapture resulted in a young man receiving a scratched face. Eventually the monkey was caught, not at the Monkey Rack (wouldn't that have been perfect?) but at the tennis ground after jumping onto a ladies shoulder and subsequently being put in a basket. Upon return to his cage, his companion monkey was apparently 'glad to see the wander return'.

Lightning Strike or Meteorite?

In April 1933 a curious incident occurred on Bridge Lane that caused a deal of speculation as to its cause:

> A young man named Jack Wilson, resident in Lister Street, was passing Oakroyd Terrace, and saw what he described as a 'flash of light' at the bottom of a poplar tree. It was a blue flash. He ducked his head, and when he looked again there seemed to be smoke around the base of the poplar tree. He was carrying an iron bar under his arm, and this was knocked clean away.

There were some who thought a meteorite had landed as a result of the thunderstorm, so the paper printed further analysis of the phenomenon of lightning to clarify the matter in the public mind, and to dispel some of the wild speculation:

Residents gather outside their homes on Bridge Lane to assess the damage caused by a thunderbolt lightning strike, which resulted in many windows being broken in the area. Contrary to popular belief at the time, a meteorite hadn't landed. (Sally Gunton)

A lady asked after the storm if the thunderbolt had been found, and when it was explained that with lightning and thunderbolts and balls of fire which are sometimes said to be associated with such displays have no tangible substance, she declared quite emphatically that she knew better because she had one. What she had of course was a portion of a meteorite...

...The event on Saturday evening, however, is explained much more simply and quite clearly as the effect of lightning.

So the matter was suitably clarified and laid to rest in the annals of the town's history. One mystery remains, however. What on earth was Jack Wilson doing in a residential district of Ilkley on a stormy Saturday teatime carrying an iron bar under his arm?

DID YOU KNOW?

Where is 'Sparrow Park'? This long-forgotten appellation is the name of the small triangle of land at the junction of Springs Lane, Bolling Road and Wheatley Road. It came to light quite by chance while looking through an old *Gazette* from 1937. The council were considering improvements to Bolling Road, and as many motorists visiting the nearby Coronation Hospital turned their cars around at this junction, it was thought useful to round off the corners. During the debate one of the councillors, Dr Whitfield, happened to remark that he believed the area was called 'Sparrow Park'.

No doubt dating back into the mists of time when Bolling Road was but a mere rustic lane leading to the village of Wheatley a mile or so to the east, this is the only mention of the name 'Sparrow Park' that I have (so far) come across.

Sparrow Park.
(Mark Hunnebell)

Acknowledgements

Thanks are due to many who have helped in the compilation of this book.

To all the staff at the Ilkley Library for their assistance in granting me access to the *Ilkley Gazette* records and my endless requests for the cupboards in the Local Studies room to be opened, thanks for your patience.

Sally Gunton for her seemingly inexhaustible collection of photographs. Without Sally's pictures many local history books would be far less interesting.

The *Ilkley Gazette* for use of photos and quotes from past editions.

Caroline Brown for her assistance in familiarising me with the library scanner, and the photograph of the skating rink staff and band.

The very helpful staff at Hartley's for lifting the trapdoor and allowing me to see the Victoria Hall swimming bath. (That's been on my bucket list since about the age of seven!)

My very good and trusted friend Matt Linley for his assistance in backing up my photo and text files, so all of the information I have is safe in case of the unthinkable.

My parents, Edwin and Margaret Hunnebell, for family photos and interesting anecdotes of their life in Ilkley.

Finally, of course, my partner Joanne Everall, who has not only shared my life since 1988 but also puts up with my mountains of notes, papers, files and photos as well.